POSTERS

OF THE
GREAT WAR

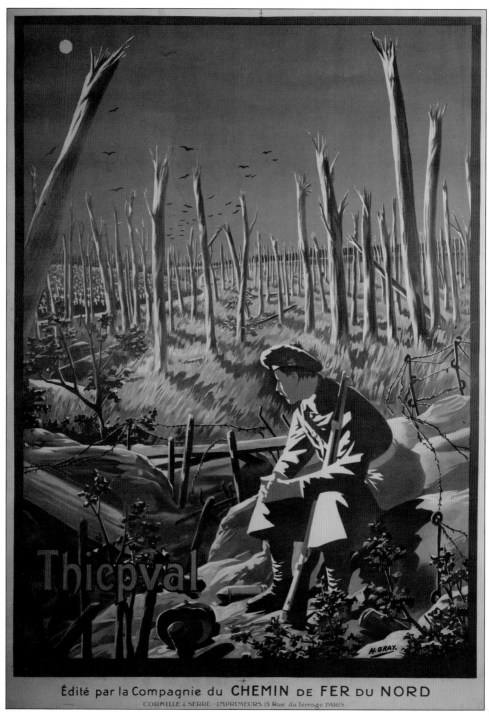

Édité par la Compagnie du **CHEMIN** DE **FER** DU **NORD**

CORNILLE & SERRE - IMPRIMEURS, 19 Rue du Terrage, PARIS.

Frontispiece. A classic piece of imagery. A soldier of the 36th Ulster Division sits in the splintered, moonlit remains of Thiepval Wood as crows wheel overhead. It is beautiful but with a slightly sinister overtone, and was commissioned to promote the 'Northern France Railway Company', presumably to encourage visitors or 'pilgrims' to visit the old battlefields. The artist was a Frenchman, Henri Grey, who was a prolific poster artist, specialising in colourful advertisements, although little is now known of him.

POSTERS
OF THE
GREAT WAR

Frédérick Hadley
and Martin Pegler

Published in Association with
Historial Museum of the Great War, Péronne, France

Pen & Sword
MILITARY

First published in Great Britain in 2013 by
PEN & SWORD MILITARY
an imprint of
Pen & Sword Books Ltd,
47 Church Street,
Barnsley,
South Yorkshire
S70 2AS

ISBN 978 178159 289 2

Typeset by CHIC GRAPHICS

Printed and bound in India by
Replika Press Pvt. Ltd.

Pen & Sword Books Ltd incorporates the Imprints of
Pen & Sword Aviation, Pen & Sword Family History, Pen & Sword Maritime,
Pen & Sword Military, Pen & Sword Discovery, Wharncliffe Local History,
Wharncliffe True Crime, Wharncliffe Transport, Pen & Sword Select, Pen &
Sword Military Classics, Leo Cooper, The Praetorian Press, Remember When,
Seaforth Publishing and Frontline Publishing.

For a complete list of Pen & Sword titles please contact
Pen & Sword Books Limited
47 Church Street, Barnsley, South Yorkshire, S70 2AS, England
E-mail: enquiries@pen-and-sword.co.uk
Website: www.pen-and-sword.co.uk

Contents

Historial de la Grande Guerre

Museum of the Great War

(Péronne – Somme – France)

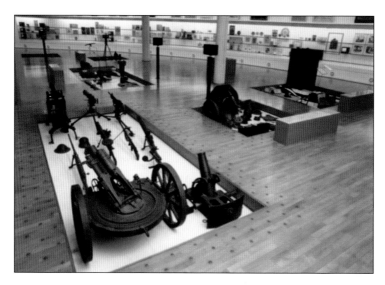

The Historial Museum of the Great War is an internationally acclaimed museum that explains the Great War in a different manner.

Located on the very site of the bloodiest battle of the First World War, the museum presents and compares the three main belligerent nations on the Western Front – Great Britain, France and Germany. It recaptures the mentalities of the front and of the civilians to shows how these were drastically modified by the war.

The Somme in 1916 was the biggest battle of the First World War with over a million casualties in less than five months of fighting. The losses totalled 420,000 for the British, 420,000 for the Germans and 200,000 for the French. The battle is most remembered for its first day: on 1 July 1916 more than 19,000 British men were killed and 40,000 others were wounded. That day still is the bloodiest in the entire history of the British army.

The ground would be fought over again during the 1918 battles. By the end of the war combatants from well over twenty-five nations had fought on the Somme, perhaps making it the place that best describes the World War. Americans, Australians, Canadians, Chinese, Indians, Irishmen, Moroccans, New Zealanders, Senegalese, South Africans ... had all come to the Somme.

The Historial museum of the Great War explains these events in the wider context of the war.

The visitor can discover the Great War from its root causes to its lasting consequences.

Through their moving display, favouring both understanding and emotion, the five main rooms illustrate life in the lines and on the home front. The weapons, uniforms, military gear and personal objects are displayed in the centre of the rooms: placed in shallow pits in the floor, they powerfully evoke the men's sufferings. The showcases around the galleries display civilian artefacts showing the lives, tools and games of the women and children.

The chronological display makes it possible to understand the attitudes of the times and see how the war changed the world for ever. Visitors can also reflect on today's world and its challenges.

The museum is unique as it systematically compares the three main nations on the Western Front. For each theme, the visitors can see the differences as well as the similarities in the ways Great Britain, France and Germany mobilised their populations for war.

It is one of the biggest public collections devoted to the First World War: the museum keeps over 70,000 items including more than 1,000 posters. Most visitors remember the impressive etchings by Otto Dix "The War". These fifty pictures show the artist's war experience, mostly on the Somme, and are a monument to the men's suffering. This complete series is unique in public collections.

For all these reasons, as well as its Le Corbusier-inspired architecture subtly combining with the brick château, the Historial was given the *European Museum of the Year Award* in 1994.

Open every day from 10 am to 6 pm (The museum closes one month every year between mid-December and mid-January)

Museum in three languages
Free audio guides are available in English, French, German and Dutch
Admission free for temporary exhibitions.

The book and souvenirs shop and the museum café welcome all.

CULTURAL EVENTS all year long. Consult our programme on our website: www.historial.org

Historial de la Grande Guerre – Château de Péronne – BP 20063 - 80201 Péronne cedex - FRANCE
Tel. +33 (0)3 22 83 14 18 – Fax +33 (0)3 22 83 54 18
www.historial.org– info@historial.org

The Thiepval Visitor Centre
Run by the Historial, the Thiepval Visitor Centre offers full facilities for the thousands of visitors to the Memorial: a shop, an AV theatre, and a presentation about the Memorial and what happened there during the war.

Preface

Posters are at the same time a medium, an artistic technique and a content. As a result, the posters of the Great War can be understood through at least two distinct approaches: they can be sorted through their aim (collecting money, encouraging recruitment, giving out information and orders) or by the representations they use to illustrate and reinforce the message. In the latter case, use of allegories, human characters and beasts drawn in specific ways can create various emotions such as pride, fear or revulsion.

This book has been structured to reflect elements of both these approaches. The main aims of posters determined their content during the war. The first chapter is therefore devoted to Recruiting, although many countries could rely on draftees. The second chapter deals with the main concern of warring nations: raising the resources necessary to achieve victory. This mobilisation of 'Loans and Money' was made possible through different representations of the war. The next chapters present successively the figures of the 'Soldier' in all their variety, the more (or less) dehumanised figures of the 'Enemy' and the longed-for figures of the 'Family and Home Front'. Through all of these figures, it is possible to touch upon a diversity of ideals, welfare causes or even simple causes for concern. The chapter on 'Films' gives yet another approach to how the war was represented and imagined during and after the fighting. It provides a natural transition to the 'After the War' chapter, which shows the lasting impact of the Great War on individuals and societies.

All the posters shown in this book are part of the Historial's collection. The Museum of the Great War is located in Péronne (Somme, France).

Introduction

The early art of the poster

Until the arrival of radio and television, and despite the growing influence of newspapers, the poster was the major medium for the mass communication of news or regulations to the population. The Great War was no exception to that, and can even be considered the first mass propaganda war via illustrated colour posters.

The use of posters for the purposes of informing the public is as ancient as written language itself. Although we may believe that it is a twentieth-century phenomenon, it has its antecedents as far back as ancient Greece, where proclamations were read out and the written texts then put up in public places. In medieval Europe, where literacy rates were generally low, notices of public events were exhibited and it was left to the educated minority, such as priests, to read them and inform local people of unfolding events. The most popular tracts were those carrying songs and ribald ditties poking fun at local and national politicians, although these could result in severe penalties for those believed responsible for them. Nevertheless they were hugely popular and often carried within them a great deal of information, invaluable at a time when there were no daily newspapers. Generally they took the form of handbills, which were bought and passed around taverns for the amusement of the locals.

From the start posters were an affirmation of who controlled power: being able to proclaim new rules reminded all concerned of who decided what those rules were. In troubled times it was also a way of trying to keep events under control. During both the French Revolution and the Franco-Prussian war of 1870-1871 proclamations twisted facts so as to show events in the best possible light. Because of this role, the history of posters was often intertwined with that of censorship. At first, authorisation for their use was mandatory and even during the nineteenth century French advertising posters could only be used within shops. It was not until the introduction of the law on the freedom of the press on 29 July 1881 that political posters could be put up in France. They then benefited (and still do) from especially designed places where it is forbidden to damage them.

The methods of addressing the public through this medium evolved

RIFLE CORPS!

COUNTRYMEN!

LOOK, BEFORE YOU LEAP:

Half the Regiments in the Service are trying to persuade you to Enlist:

But there is ONE MORE to COME YET!!!

The 95th; or,

Rifle REGIMENT,

COMMANDED BY THE HONOURABLE

Major-General Coote Manningham,

The only Regiment of RIFLEMEN in the Service:

THINK, then, and CHOOSE, Whether you will enter into a Battalion Regiment,

or prefer being a RIFLEMAN,

The first of all Services in the British Army.

In this distinguished Service, you will carry a Rifle no heavier than a Fowling-Piece. You will knock down your Enemy at Five Hundred Yards, instead of missing him at Fifty. Your Clothing is GREEN, and needs no cleaning but a Brush. Those men who have been in a RIFLE COMPANY, can best tell you the comfort of a GREEN JACKET.

NO WHITE BELTS; NO PIPE CLAY!

On Service, your Post is always the Post of Honour, and your Quarters the best in the Army; for you have the first of every thing; and at Home you are sure of Respect - because a BRITISH RIFLEMAN always makes himself Respectable.

The RIFLE SERGEANTS are to be found any where, and have orders to Treat their Friends gallantly every where.

If you Enlist, and afterwards wish you had been a RIFLEMAN, do not say you were not asked, for you can BLAME NOBODY BUT YOURSELF.

GOD SAVE the KING! *and his Rifle Regiment!*

A recruiting poster from about 1803 calling for volunteers to join the newly formed 95th Rifle Regiment. Various enticements were on offer, amongst which were the issue of a green (rather than red) tunic and better living conditions than those of the ordinary infantry. It was a very early attempt at using posters to persuade men to join the army, by showing what a splendid life it was, pre-dating similar posters of the Great War by more than a century.

slowly but surely. Already in 1876 the first centralised political poster campaign had taken place: the same poster would be sent out from Paris to all candidates, who only needed to fill in their names and local details. The principles of Attraction/Repulsion were used to promote one's ideas and discredit the opponent's. Increasingly, posters insisted on what was unifying instead of what was divisive, even using humour to achieve this. The most successful posters consequently had from early on an influence on how the population thought. Posters were beginning to be created that had very specific aims – to get young men to join the army and fight – and this was a trend that would continue as time progressed. Local recruitment posters appeared in their thousands during the American Civil War; while the Crimean War did not see quite so much in the way of posters promoting the war, its cessation resulted in a wealth of 'peace posters' across Britain's major cities, as the country celebrated its victory. The Boer War resulted in the creation of a rather sharper image with the use of the wounded 'Tommy Atkins', a rough bandage around his head, rifle and bayonet tilted defiantly towards an invisible foe. This image had a powerful effect on the Victorian mind and appeared on posters and in advertisements, and spawned a wealth of statuettes that adorned parlour mantelpieces up and down the land.

It must be specified that early posters did not have any illustration. The first French illustrated political poster only dates back to 1830 but the technique would become widespread within thirty years.

Producing posters
Between 1795 and 1798 Prague-born Aloys Senefelder had developed a technique for printing music scores that enabled artists to paint directly (though back-to-front) on a calcareous stone and then reproduce it. This German improvement made it much easier to produce illustrated prints. Until then printing had been a matter of engraving wood or metal to create relief; Senefelder's invention rapidly spread throughout Europe for only the top of the die would touch the paper and all other elements were eliminated.

For bigger posters, rollers were made out of zinc, which was more durable for bigger print runs. In 1837 Godefroi Engelmann introduced colour printing, each colour having its own roller. The colours had to be added carefully to avoid overlapping. This is where the lithographer's skill was indispensable in order to obtain pure colours or the correct mix. By 1865 J. Brissat was able to print runs of several thousand large format copies.

A year later Jules Cheret brought to Paris the chromolithographic techniques he had studied in London. New forms were explored, and the turn of the century is usually considered as the Golden Age for advertisement posters. Cheret drew simple shapes, making understanding

Although the name actually dated back as far as 1743, and was known during the American Revolutionary War, use of the image of 'Thomas Atkins' began primarily through the Crimean War. From the mid-nineteenth century the concept of the cheery British 'Tommy' captured the public imagination and was reinforced in the public's mind by the popular poems of Rudyard Kipling, all of which referred specifically to the daring deeds of the eponymous British Tommy. The image reproduced here is from the post-Crimean War period and depicts both British and French soldiers.

Posters were much used when there was little national news available and few people could read. This 1856 example is typical: it informs readers of the end of the Crimean War, offering a public holiday and free lunch for the local poor and aged. Although it seems a long way removed from the poster campaigns of the Great War, it was an effective way for the government to disseminate information and was only a step away from the use of posters as propaganda.

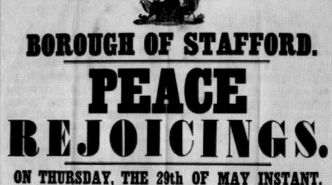

BOROUGH OF STAFFORD.

PEACE REJOICINGS.

ON THURSDAY, THE 29th OF MAY INSTANT,

IT IS REQUESTED THAT ALL

BUSINESS MAY BE SUSPENDED,

AND THE DAY KEPT

AS A GENERAL HOLIDAY,

IN ORDER TO CELEBRATE

THE RATIFICATIONS OF PEACE.

The Aged Poor, both Men and Women, will be regaled in the Covered Market Hall with Roast Beef, Plum Pudding, and Ale, at ONE O'CLOCK at noon. All Poor persons, of FIFTY-FIVE Years of age and upwards, who wish to participate in this Feast must apply for Tickets on TUESDAY NEXT, the 20th instant, at the Guildhall, Stafford, at Four o'clock in the Afternoon.

JOHN GRIFFIN, Mayor.

GUILDHALL, 15th MAY, 1856.

R. Dawson, Printer, Market Square, Stafford.

immediate, and the text was closely articulated with the picture. In Germany, as early as 1906, Hohlwein used big juxtaposed colour patches that created shades and stark contrasts. John Ruskin's Arts and Crafts Movement did not neglect posters either, and employed many of these techniques.

Collecting posters became a craze, and special fairs as well as magazines were created to support this. For example, *The Poster*, published in London from 1898 to 1901, was devoted to this art. In fact, posters started to influence even 'high art'. Pablo Picasso included advertisements for Maggi Kub soup in one of his 1912 paintings, and Mondrian and Braque mentioned other brands in theirs.

By the time the war broke out in 1914, posters were at the heart of images and representations. They reflected the political and religious convictions of societies at large and turned them into a politically mobilising message. During the conflict artists used images that offered a specific meaning, often a justification of events or even of the war itself. More traditional charcoal drawings dominated French posters to create a realist effect. Average pre-war runs of 3,000–5,000 copies ballooned to top 150,000 or even 200,000 copies during the war years. Even Théophile Steinlein, the art nouveau painter, and other artists who were notoriously left-wing anti-militarists contributed to the war effort.

The Great War saw the first mass use of illustrated posters for propaganda purposes.

Showing the war
Like other communication techniques, posters rely on different methods to convince viewers. In appearance they can be based on rational arguments to further a point; statistics or maps are often used to explain a viewpoint or as a direct answer to refute the enemy's. During the early years of the twentieth century propaganda was still considered more of a discussion between nations that allowed arguments to go back and forth. For this reason, propaganda was not negatively regarded. Germany printed many posters comparing figures with enemy nations, or maps designed to show fluctuating borders; most of these were attempts to counter Allied propaganda that depicted German culture as brutish or non-existent.

In fact, immediately upon the outbreak of the war and increasingly so in the following years, another style of communication, based on emotional impact, was also employed. Instead of addressing the reader's logic, most posters relied on the positive power of a striking image, expressing values such as patriotism, or encouraging sacrifice; they could also be adorned with rallying symbols such as flags or historical and mythical models. For example, in France images of the French Revolution would be constantly reactivated during the Great War to show 'the country in danger' and to demand that the

entire population remain mobilised. Since the nineteenth century the image of a lone knight battling monsters embodied a romantic vision of noble courage and heroism. Such historical escapism from the harsh reality is very telling, as it gives a clue as to which idealised world the warring nations aspired to. Modern heroes, usually generals and soldiers of the recent Boer War or even of the Great War, could also be called upon by poster artists.

Nevertheless, it was often considered just as easy and efficient to use negative imagery, so that fear became central to the artwork. Apocalyptic situations were prophesied if the public did not obey the text or slogan. Most of these posters depicted the homeland in flames, and encouraged hatred of the enemy. The other side could be portrayed in many unflattering ways, ranging from simple ridicule to total dehumanisation. Real and imagined atrocities were regularly shown to justify the fighting: the French catholic conservatives re-employed on a massive scale the rumour that German soldiers cut off babies' hands as souvenirs.

Be it positive or negative, the imagery employed was often well known to the public and was far from being specific to posters. It is revealing to compare these publications with others such as illustrated music scores or even children's books. Similar images and references can be traced in countless other productions but because posters were so voluminous and omnipresent, they expressed most clearly a common ground widely shared by the population at large when they did not actively contribute to shaping new representations.

British posters

The power of the Tommy Atkins image was not forgotten when the Great War turned from shield beating to real fighting, and the government was quick to make use of another, more real, character, Lord Herbert Kitchener. Already a hero of the nation through his success in the Sudan (being given the title Lord Kitchener of Khartoum), he was to become Chief of Staff for the Second Boer War. His picture first appeared in the press and was soon adapted into a poster. Choosing this living figure for a poster was a clever move, for Kitchener was regarded as a heroic figure, and by inference anyone joining the army could achieve what he had. The visual impact of the poster was, and still is, impressive. The accusatory finger and slightly hooded fixed gaze follow one around. It is, in fact, slightly sinister and slightly accusatory, but it is undoubtedly powerful. There was also a more subtle message contained within the simple text, which was soon to be used far more openly: 'He is still doing all he can for the war effort. What are you doing?' Such was its influence that the poster is still being reproduced today and has been used for advertising everything from television programmes to *Star Wars*, as well as countless personalised images. From this early example

This is possibly the most iconic of all wartime posters. It was designed by Alfred Leete (1882–1933) using the face of Secretary of State Lord Kitchener. It first appeared on the cover of the popular *London Opinion* magazine on 5 September 1914 and was hugely successful. As the *London Times* reported in early 1915: 'Posters appealing to recruits are to be seen on every hoarding, in most windows, in omnibuses, tramcars and commercial vans. The great base of Nelson's Column is covered with them. Their number and variety are remarkable. Everywhere Lord Kitchener sternly points a monstrously big finger, exclaiming 'I Want You''.' It has since become one of the most reproduced posters in modern history.

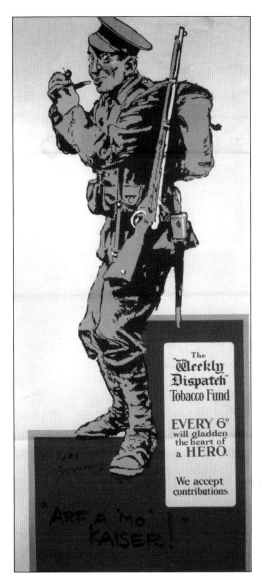

The essence of the typically cheeky Great War Tommy was captured by artist Bert Thomas, (1883–1966) in this 1914 sketch, which took ten minutes to do. Thomas was at the time serving with the Artists Rifles. He donated it to the *Weekly Dispatch* magazine, and it first appeared on 14 November 1914. As a poster, it helped to raise £250,000 for the 'Smokes For The Troops' fund. Later in the war Thomas became the official artist for the National Savings Fund campaign, and in the Second World War he produced many more well-known posters. He was subsequently awarded the MBE for his work.

sprang a vast multitude of Great War posters, varying in tone from the very simple 'Your King and Country Needs You' to the Kitchener-clone poster of John Bull demanding 'Who's Absent?' and the emotional appeal of 'Women of Britain Say Go.' Nor was Kitchener alone, for another heroic image, that of Lord Roberts VC, was also widely used. These images raised awkward questions. If a man did not enlist, if he shirked his duty, what would his friends and workmates say? Worse, how could he deal with the scorn of the women, who wanted their men to be heroes? If these early examples of poster art seem to our cynical modern eyes naïve, they were certainly effective, employing as they did guilt as a powerful means of making men join up. In postwar memoirs many veterans commented on the recruiting posters and the shame they felt at not having already joined the army. Men

who did not want to fight, and there were many, debated with their consciences over whether it was better to be a living coward than a dead hero, and most, but by no means all, opted for the latter course.

Aside from recruiting, there was a secondary reason for the mass-production of posters and this was to persuade the country of the righteousness of the war. Unlike previous conflicts, where a small professional army fought in distant foreign wars, the First World War was global and it included civilians. For the first time civilians found themselves on the front line: Scarborough was shelled by the German fleet and London was bombed by Zeppelins. Food shortages affected everyone and the government needed to win the hearts and minds of the populace. In fact, it was not only their acquiescence that was required, but, as the war progressed, also their money, for the cost of the war was to prove colossal.

Increasingly, posters were created that tried to persuade people to lend to the government, through savings stamps or war bonds, and this flow of money was vital to the war effort. Initially there was no cohesive method of producing war posters. The first body set up to try to get men to enlist was the Parliamentary Recruitment Committee, established under the chairmanship of H.H. Asquith, A. Bonar Law and A. Henderson shortly after war was declared in August 1914. They produced a large number of parliamentary recruitment posters (the exact number is not known, but runs into dozens). As the war progressed, posters had to be designed that were pure propaganda, and these were mostly created by a non-governmental organisation based in Wellington House, London, whose existence was not even known to parliament. There were also government agencies, such as the Foreign Office and the Ministry of Munitions, as well as dozens of other independent organisations, who also produced posters for public information. It was not until 1917 that the author and MP John Buchan was appointed head of the newly created Department of Information; the following year the Ministry of Information was finally established under Lord Beaverbrook. By this time the use of posters to inform, persuade or threaten had grown hugely, so that by 1918 they encompassed almost every field of endeavour one could imagine. A shortlist (and it is by no means exhaustive) covers recruitment, war funding, charity work, home life, munitions, food production, prostitution, political aims, atrocities, post-war employment, reconstruction, war disabled, tourism and a host of others. Until 1918 the employment of artists was not centrally organised in the manner of their American counterparts, and luminaries of the British art world such as Kennington, Nash and Orpen were already employed as war artists, so many of the posters were created by lesser-known but equally talented men, such as George Gawthorne. A few foreign artists had fled to Britain at the start of the war, notably Louis Raemaekers, who went on to become an

internationally respected artist and illustrator. However, it is unfortunate that so many of the posters that survive today are unsigned and their creators unidentifiable.

Although Great Britain was undeniably slow to adopt the poster as part of its war effort, propaganda soon became as vital as munitions production and within two decades the Ministry of Information was arguably to become one of the most important and powerful non-military bodies of the Second World War.

The American poster campaign
The United States had made great use of printed posters and proclamations during its formative years in the eighteenth century, particularly in the recruitment of men to fight during the Revolutionary Wars. Handbills and proclamations were everywhere in the colonies, exhorting men to join their local militia, informing them of where units met and even the whereabouts of potentially threatening British units. In a huge country with no mechanical form of communication, the poster was a vital method of informing the people. As the United States settled back into postwar peace in the early nineteenth century, it began to build itself into a powerful mechanised society using mass-productions methods quite alien to Europeans. In a simple way advertising became central to the marketing of products and by the end of the nineteenth century advertising in the United States was both sophisticated and a major business in itself that influenced the very core of American home life, and its power and impact were very clearly understood by those who manipulated it.

Unlike in Britain, where propaganda was somewhat ad hoc and initially in no way a cohesive force, from the outset of its involvement in the war in 1917 the American government decided on a rationale for its poster campaign and to that end formed the Division of Pictorial Publicity under George Creel. He believed, quite rightly, that all propaganda must be centralised to prevent duplication and wasted effort, and he co-opted one of the best known artists in the United States, George Gibson, to head the division. Gibson knew almost everyone worth knowing in the art world, and it was through him that an extraordinary array of talent was assembled. It is to the great credit of artists such as Leyendecker, Christie and Groesbeck that they gave their services to the government free, at a time when illustrations by top artists could fetch up to $10,000 apiece. The numbers involved are prodigious, for some 279 artists and 33 cartoonists were employed, and their output resulted in 2,500 different posters, of which some 22 million examples were printed. As a comparison, this was a greater output than that of all the other countries that took part in the war combined. Unlike the UK, where the campaign was largely anonymous, in

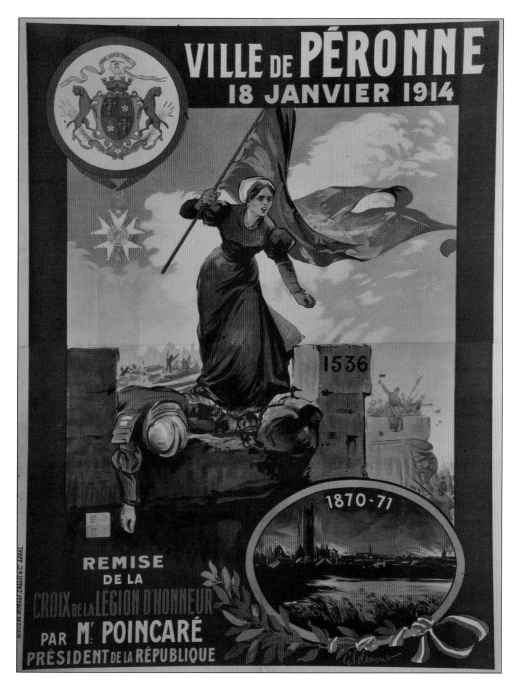

'City of Péronne. 18 January 1914. Ceremony for the awarding of the Legion of Honour Cross by Mr. Poincaré, President of the Republic.'

Péronne was a strategic town in protecting the kingdom of France's borders. The figure of Marie Fouré is a reminder of the city's successful resistance during the Spanish siege of 1536. During the Franco-Prussian war of 1870–71 the city was again unconquered. For that reason it was awarded the Legion of Honour in January 1914. It is ironic to know that war was then not considered a significant threat.

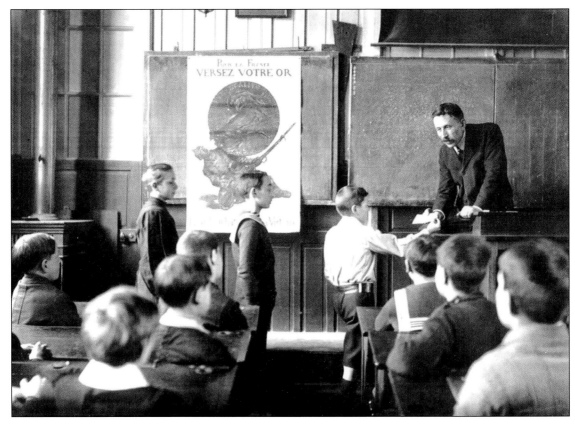

This propaganda photograph shows the major role played by posters during a loans drive in a French school. This carefully constructed image clearly states that everyone was supposed to take part in the war effort and that propaganda was aimed at all, even the youngest.

the United States nationally known personalities such as Douglas Fairbanks and Mary Pickford attended rallies, and Charlie Chaplin made a short propaganda film at his own expense.

As in the UK, specific areas were targeted, although the focus was different. Recruitment in the United States was not as problematic as it had become in England through use of the Selective Service Act of 1917 (the draft), which enlisted men between 21 and 31 years of age, resulting in some 24 million men being registered. By the end of 1918 the United States planned to have over 4 million men in France. Nevertheless, recruitment posters were considered important and thirty-six separate artworks were commissioned to cover all of the armed forces as well as the ordnance industry. War finance was regarded as a higher priority than in England, hence the proportionately larger number of War Loan posters. The war cost the United States a million dollars per hour, and through the medium of

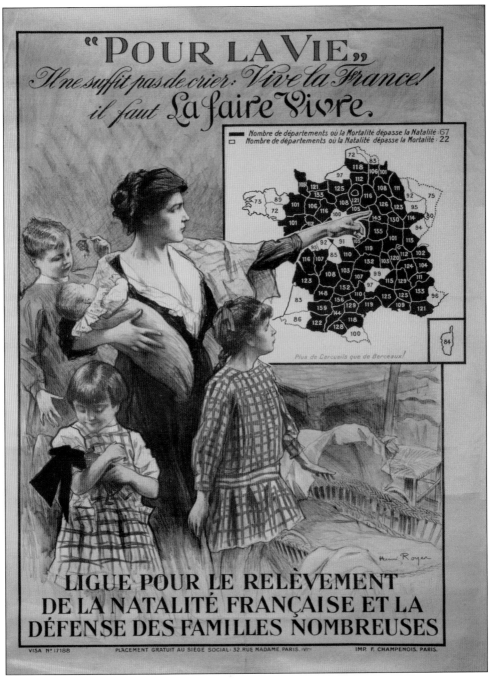

'For life. It is not enough to shout "Long live France"! One must make it live. League for increasing French birth rates and for defending big families.'

In the pre-war years France's demographic trends became a real cause for concern among patriots: the black areas on the map show where the population was decreasing. The gap between the 40 million Frenchmen and 86 million Germans (in 1914) was widening. For nationalists, this jeopardised the reconquering of the 'lost provinces' of Alsace and Lorraine, highlighted by the mother's insistent gesture.

posters between 1917 and 1918 it raised $24 billion dollars by offering a system of five different types of loan. To put this into context, Britain and France combined managed to raise only $20 billion in four years. Both during and after 1918, in line with the United States' prewar position as a neutral and peaceable nation, there was a greater emphasis towards posters that sought to counter the humanitarian crisis that was wreaking havoc across Europe. This is seen by the numbers of Red Cross, YMCA, Boy Scout and other charity posters; these organisations raised colossal amounts of money to aid the destitute, disabled and unemployed. Food production was another vital factor: the United States was seen as the world's bread-basket, and supplied not only Britain, but much of occupied Europe with food, some 5 million tons of wheat going to Belgium alone. The United States continued to offer Victory Loans, which were used to assist with reconstruction and help with the colossal war debt that had accrued.

There is little doubt that, for the Allies, the poster campaign had turned the war into a visual one. This was amplified by the widespread use of cinema and photographic images, which began to alter the way in which the public saw the world – a change that has continue unabated to the present day. Perhaps we do not appreciate just what a fundamental change was wrought by those early images appearing on hoardings and noticeboards, for today we live in a world that is almost wholly visual: television, computer screens, cinema, games consoles and advertisements utilising every conceivable type of media flood our daily lives. All of this was utterly inconceivable to the ordinary man of 1914. The nearest that he would get to visual images was perhaps a poor quality photograph in a newspaper, or postcards of local attractions. The Great War was to change that for ever, and to introduce a means of propaganda that was novel, persuasive and, above all, powerful. The Great War was the first media war. The twentieth century had arrived.

Chapter 1

Recruiting

It is no coincidence that the largest number of posters in the 'Recruitment' category are British. Before 1914, both France and Germany had obligatory military service for men, so that in August 1914 the French army already numbered 1,300,000 men, including colonial troops. The German army was even bigger, comprising in 1914 almost 1,750,000 men, and there were a similar number in reserve, as all men between the ages of 17 and 45 were required to undergo compulsory service. These were significant figures compared to the size of the British Regular Army at the outbreak of the war, which was a little over 710,000 strong *including* reserves, and of these only 80,000 men were sufficiently equipped to go to war. The majority of the army was spread thinly across the world, policing Britain's far-flung colonial interests. In part the reason for this was that the British had always been opposed to conscription, and even the idea of retaining a standing army was a contentious one.

Initially, 100,000 volunteers were asked for in a direct appeal by Lord Kitchener, fronted by the famous 'Your Country Needs You' poster, which was issued on 7 August 1914. The government believed that any more men would simply cause logistical problems, but in the event such was the rush to join the colours that by January 1915 over a million men had volunteered. The initial belief of the British high command that the war would be short and sharp soon vanished in the smoke of the battles of 1914. It soon became painfully clear that far more men would be needed than had ever been thought possible. In France the British Expeditionary Force had lost 90,000 men in the first three months of the fighting – more than its original size, although curiously the near-defeat of British forces in the early battles such as Mons helped fuel enlistment. Nevertheless, the government was becoming increasingly uneasy about the rate at which men were being killed and wounded, and the inability of the army to replace them. This, of course, was not unique to Britain: French and German losses in 1914 had also been

huge, but those countries still held sufficient reserves for the numbers to be made up. Britain's problem was that by late 1915 the rate of volunteering was slowing, for by then the numbers of men enlisting had dropped to around 70,000 per month. This was not enough to maintain the level of manpower needed, and both posters and other popular media such as music halls were used to recruit more young men. The tone of the posters being produced began to change from straightforward patriotic pleas to 'Fight for King and Country' to more subtle messages. Imagery became more frightening and graphic as propaganda became better organised. Rumoured German atrocities, the threat of invasion and even the capture of civilians and implied rape appeared on billboards around the country. There was little doubt that such methods were needed as the war progressed. Conscription had to be introduced in January 1916 for single men but even this was insufficient: the Somme battles alone, for example, required 3,000 replacement soldiers *per day*. In the United States the army was sufficiently large, at 98,000 men, to send troops to Europe as soon as hostilities were declared, so that there were 14,000 Americans in France by June 1917 with an additional 25,000 arriving every week. By the summer of 1918 a million American servicemen were in France. In part these numbers were attainable only through conscription, but this did not prevent the American government from embarking on a huge poster campaign to encourage voluntary enlistment, but generally such posters tended to be aimed less at enlistment and more at promoting the war effort. It is doubtful whether recruiting posters had any effect whatsoever in any country by late 1917, although they continued to be produced. Without the United States' entry into the war, it is questionable how much longer Britain and France could have continued hostilities. Unlike weapons or money, the numbers of soldiers that could be created was finite.

ARMÉE DE TERRE ET ARMÉE DE MER

ORDRE
DE MOBILISATION GÉNÉRALE

Par décret du Président de la République, la mobilisation des armées de terre et de mer est ordonnée, ainsi que la réquisition des animaux, voitures et harnais nécessaires au complément de ces armées.

Le premier jour de la mobilisation est le *Dimanche Deux Aout 1914*

Tout Français soumis aux obligations militaires doit, sous peine d'être puni avec toute la rigueur des lois, obéir aux prescriptions du **FASCICULE DE MOBILISATION** (pages coloriées placées dans son livret).

Sont visés par le présent ordre **TOUS LES HOMMES** non présents sous les Drapeaux et appartenant :

1° à l'**ARMÉE DE TERRE** y compris les **TROUPES COLONIALES** et les hommes des **SERVICES AUXILIAIRES** ;

2° à l'**ARMÉE DE MER** y compris les **INSCRITS MARITIMES** et les **ARMURIERS** de la **MARINE**.

Les Autorités civiles et militaires sont responsables de l'exécution du présent décret.

Le Ministre de la Guerre, Le Ministre de la Marine,

'Order of general mobilisation.' A simple administrative poster with two flags announced the French general mobilisation. Each mayor had received an envelope containing several copies. When the Prefect gave the order, the envelope would be opened and the exact date would be added. The image of French soldiers happily going off to war with flowers attached to their rifles is largely a myth. Despite small nationalist demonstrations in Paris, most of the population, still very rural, regretted not being able to harvest the crops. The overall feeling was one of quiet determination to defend country and family against what was perceived as German aggression.

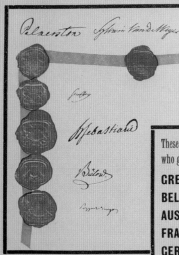

An early poster outlining the Treaty of Belgium and highlighting the apparent indifference of the German Chancellor to its content. The fact that the treaty was signed thirty years before the Franco-Prussian War of 1870 and bore little relevance to the politics of 1914 was carefully ignored. The appeal was to the emotions rather than to historical accuracy.

Another reference to the 'Scrap of Paper'. The detail in this 1914 painting by war artist Clarence Lawson Woods (1878–1957) is worth a second look as the rather pensive-looking Highlander's uniform and equipment have been very accurately reproduced, an unusual feature in posters of this type. The explanation is that Wood had served in the army as a Kite Balloon officer, and was decorated for gallantry. He worked for the *Graphic*, the *Strand*, *Illustrated London News* and *Boy's Own* newspaper but after the war he became a recluse. However, his lifelong concern for the welfare of animals earned him a fellowship of the Royal Zoological Society in 1934.

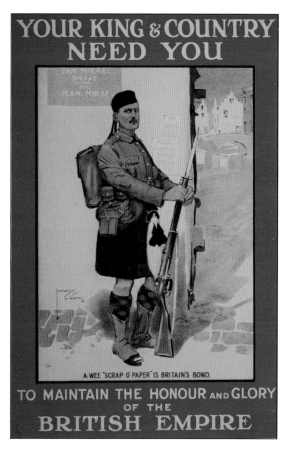

YOUR KING & COUNTRY NEED YOU

A WEE "SCRAP O' PAPER" IS BRITAIN'S BOND.

TO MAINTAIN THE HONOUR AND GLORY OF THE BRITISH EMPIRE

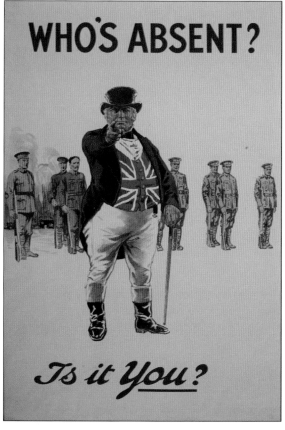

WHO'S ABSENT?

Is it You?

Although the artist is unidentified, this is the first depiction of John Bull in a military poster, and dates to 1914/15. Created in 1712 by Dr John Arbuthnot, 'John Bull' represented a typical simple, good-hearted English yeoman, not particularly heroic but always adhering to the British sense of fair play. He proved to be the ideal representation of the ordinary Englishman and was to appear regularly in posters during the Great War, being represented in the United States by the figure of Uncle Sam.

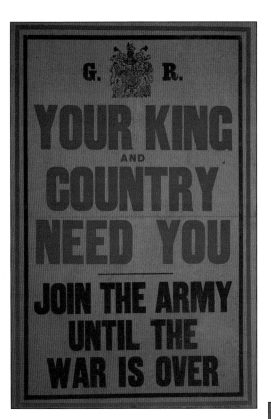

This is one of the simplest but most often reproduced recruitment posters of the war. The message is clear and unmistakable, and examples were reproduced in varied sizes: as huge bill-hoardings, large shop-window posters and newspaper pages. They were everywhere, and are still one of the most commonly found posters of the war, although in many respects the sentiments today would no longer be thought of as relevant.

A more subtle poster, pricking the conscience of the ordinary man in the street, this embodies many elements of later posters, particularly the fourth item, which pre-dates the later, famous, 'What Did You Do In The War?' poster. It plays on the fact that men who did not join up would have to wrestle with their consciences in later life.

4 QUESTIONS to men who have not enlisted

1. IF you are physically fit and between 19 and 38 years of age, are you really satisfied with what you are doing to-day ?

2. Do you feel happy as you walk along the streets and see other men wearing the King's uniform ?

3. What will you say in years to come when people ask you "Where did you serve in the great War" ?

4. What will you answer when your children grow up and say, "Father, why weren't you a soldier, too" ?

ENLIST TO-DAY.

A rather unusual literary example, quoting Shakespeare's Lady Macbeth (*Macbeth*, Act 3, Scene IV). Although it is arguable that the message would be lost on many of the ordinary public today, in Edwardian England Shakespeare was taught in schools and widely read, and it would certainly have struck a chord with many of the men at whom it was aimed.

Another early poster of about 1915 using an emotional appeal, this time purportedly from the children of England. Although now the concept of children urging their fathers and brothers to go and fight seems inconceivable, it must be remembered that to the Victorian generation of 1914 God and the mother country were sentiments that were taken very seriously indeed. The small quote at the bottom from Admiral Lord Nelson, 'England expects ...', is a nice additional touch.

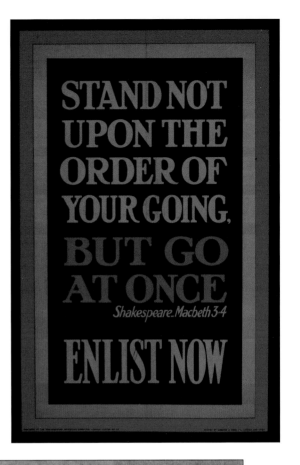

MORE MEN

ARE WANTED FOR

HIS MAJESTY'S ARMY

WHO MAY ENLIST.

All men who are 5ft. 3ins. and over, medically fit, and between 19 and 38, and all old soldiers up to 45.

TERMS OF ENLISTMENT.

You may join for the period of the War only if you do not want to serve for the ordinary period of the regular soldier. Then, as soon as the War is over, you will be able to return to your ordinary employment.

PAY.

Ordinary Army Pay (the lowest rate of pay is 7s. a week, less 1½d. for Insurance). Food, Clothing, Lodging and Medical Attendance provided free.

SEPARATION ALLOWANCES.

During the War the State, by the payment of Separation Allowance, helps the soldier to maintain his wife, children or dependants. The following are the weekly rates for the wife and children of a private soldier, including the allotment usually required from his pay:—

	Government Separation Allowance	Largest Allotment required from Soldier	Weekly Income Secured to Family
	s. d.	s. d.	s. d.
For Wife only	9 0	3 6	12 6
„ and 1 Child	14 0	3 6	17 6
„ and 2 Children	17 6	3 6	21 0

For each additional child an additional Separation Allowance of 2s. is issuable.

Families living at the time of enlistment in the London Postal area are allowed by the State 3s. 6d. a week extra as long as they continue to live there.

Fuller particulars as to Separation Allowance, and as to Allowances to the Dependants of Unmarried Soldiers, and to the Motherless Children of Soldiers, can be obtained at any Recruiting Office or Post Office.

PENSIONS for the DISABLED.

Men disabled on service will be entitled after discharge to benefits under the Insurance Act IN ADDITION TO the Pension given by the War Office for partial or total disablement.

PROVISION for WIDOWS and CHILDREN.

The widows and children of soldiers who die on active service will continue to receive their Separation Allowances for a period which will not in any case exceed 26 weeks, and afterwards they will receive, SUBJECT TO CERTAIN QUALIFICATIONS, pensions at various rates.

HOW TO ENLIST.

Go to the nearest Post Office or Labour Exchange. There you will get the address of the nearest Recruiting Office, where you can enlist.

MEN ARE WANTED — ENLIST NOW.

PUBLISHED BY THE PARLIAMENTARY RECRUITING COMMITTEE, 12, DOWNING STREET, S.W. Poster No. 33.

The practical terms and conditions for men enlisting were little understood, and the army was regarded by all but the lowest class of men as a very poor choice of career. This poster tries to redress this somewhat by spelling out the financial benefits. At a time when prospects for working-class men were a life of long hours (the average working week in 1914 was 58 hours), low pay (average weekly pay was 16 shillings 9 pence) and little chance for economic or social advancement, the ability to join the army, be well fed and adequately paid as well as seeing foreign countries was a tempting one. Indeed, pay of 21 shillings a week for a married man with two children was a not unreasonable income.

This poster follows on from the previous one, depicting a well-fed, healthy-looking soldier, expressing his delight with army life. Bearing in mind one-third of the working class males who enlisted in 1914 were recorded as being malnourished, this simple poster must have had considerable appeal. It is signed only as 'OR', and the artist is unidentified, but the poster is dated June 1915. The title duplicates a very popular music-hall song of the time.

This clever image crosses all social boundaries, showing men from every possible class – upper, legal, white collar and blue collar – queuing up to enlist and gradually being transformed into a cohesive armed force. In practice, having to deal with a new type of volunteer soldier, who was more intelligent and better educated than traditional recruits, posed significant problems for the army in 1914.

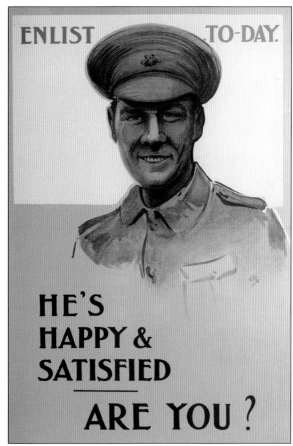

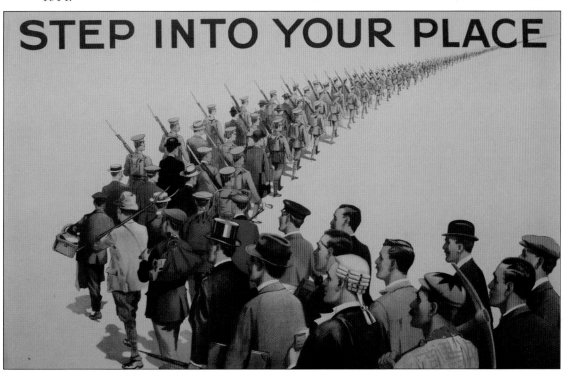

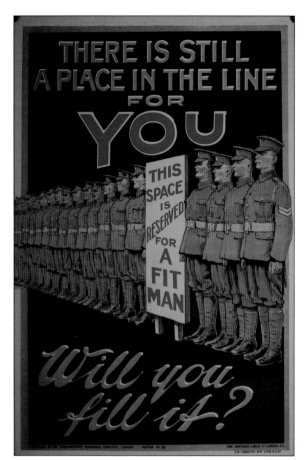

In a similar theme, there was plenty of space in the army for any able-bodied man to fill. The prime reason that they were needed – because of the steadily rising numbers of casualties – was omitted. During the Somme offensive replacement men were needed at the rate of 3,000 per day.

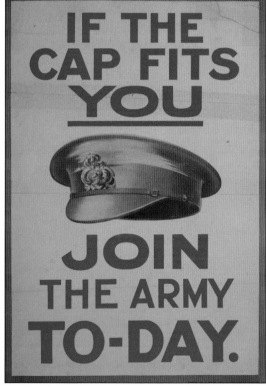

Certain visual images and themes recur in posters during the war, and uniform and equipment (in this instance, a cap) is one of them. The expression 'If the caps fits' was a commonplace one and here it has been adapted to encourage men to volunteer.

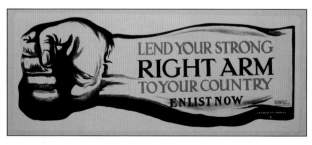

This illustration is an interesting one: its visual appeal seems more suited to manufacturing than it does to fighting, and it is a curiously Germanic image. It is a rare poster and does not appear to have been produced in large numbers, perhaps because it did not produce the desired result.

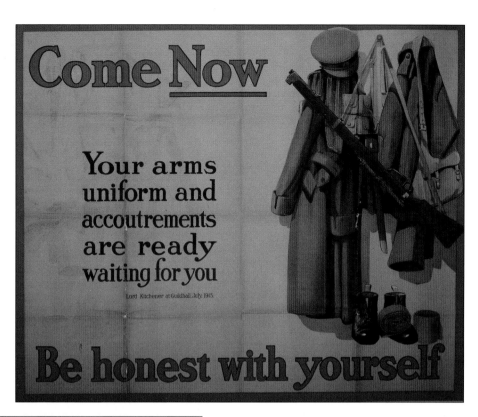

This interesting depiction of the uniform and equipment carried by the average infantryman is a Parliamentary Recruiting Committee poster, probably dating from 1915, as no steel helmet is shown. What is curious is the request 'Be honest with yourself', the meaning of which is rather open to interpretation. Possibly the viewer was supposed to feel guilty about not being in uniform.

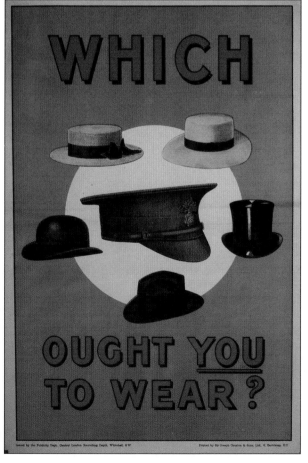

Another variation on the theme of headgear, which would have meant much more to the men of 1914, when social classes were differentiated by hats. In this image the headgear (clockwise from top left) represents the boater of a student or young man, the straw hat of a man-about-town, the top hat of the upper and professional classes, the trilby of a middle class man and the bowler of a working man. Oddly, the universally worn cloth cap, the badge of the working class, is not represented here.

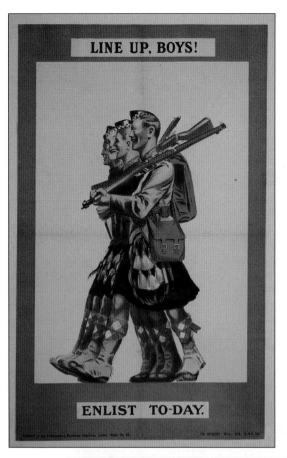

LINE UP, BOYS!

ENLIST TO-DAY.

Another 1915 poster, this time from January, with more smiling soldiers. The image, reminiscent of a *Boy's Own* comic illustration, creates an impression of great bonhomie, and the red-cheeked laughing Highlanders imply that the war was really a jolly affair, which may have been appropriate in 1914 but was far removed from the truth by 1915.

Maps feature quite frequently on wartime posters, but this is an unusual image that makes use of two posed figures that have been photographically reproduced across a map of southern England and northern France. The simple message – that a man could virtually step across the Channel and fight – belied the complex process of recruiting, training and equipping a vast civilian army but the image is nonetheless dynamic and uses a technique that is very modern in its application.

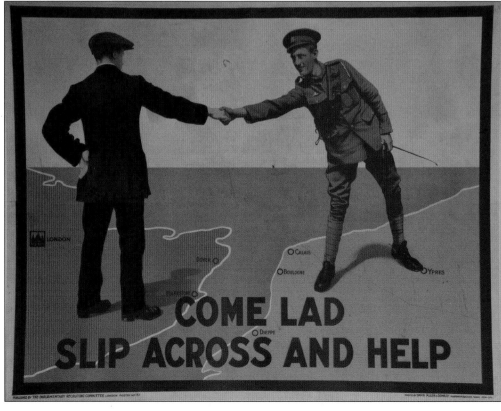

COME LAD SLIP ACROSS AND HELP

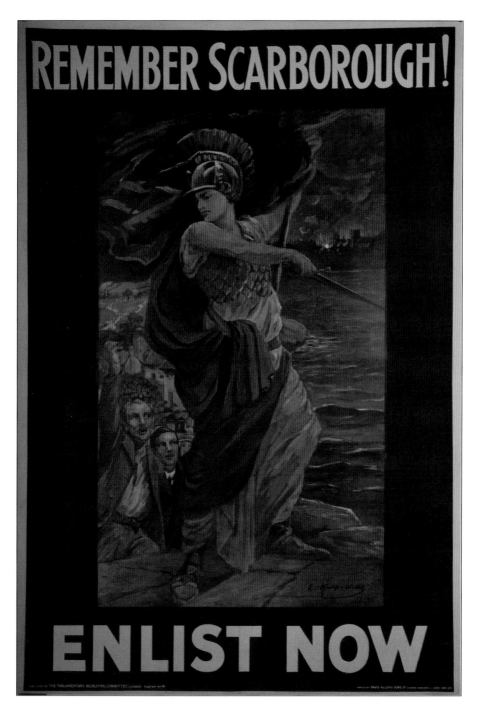

The event depicted here enables this poster to be accurately dated, for it recalls the shelling by the German fleet of Scarborough, Hartlepool and Whitby on 16 December 1914. The attack resulted in 137 deaths and 592 injuries, and sparked massive outrage in England. Finely painted by Lucy Kemp-Welch (1869–1958), it shows an angry Britannia pointing her sword across the water, while the town of Whitby blazes behind her. A very talented landscape artist, Kemp-Welch also specialised in horses and provided the illustrations for Anna Sewell's famous book *Black Beauty*.

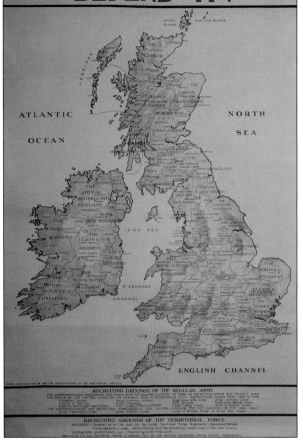

IS YOUR HOME HERE?
DEFEND IT!

A simple but effective map of the British Isles used here not only as a recruiting guide, but also as a visual indicator of the area that was under potential threat from an aggressive enemy. By showing the whole of the British Isles, it made the threat from Germany appear even more dangerous, for the implication was that nowhere was safe from possible German invasion. Similar maps were used in the United States to reinforce the threat, real or imaginary, to their freedom.

E.V. Kealey's famous image from May 1915 shows a distraught-looking family watching their menfolk march away. To an extent it parallels the earlier poster, 'From the children of England'. At this early stage in the war there was little role for women to play, and they were usually depicted as helpless victims. This changed dramatically once the war industry gathered pace after 1915 and women became an integral part of the manufacturing workforce. Little information survives about Kealey's career but he was a prolific poster artist and produced several important works for the war effort.

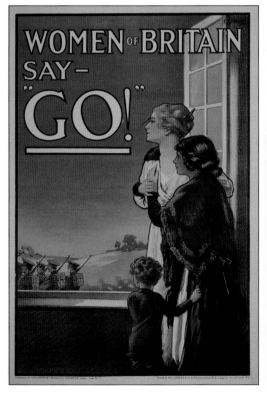

It is seldom possible to identify individual British poster artists (German and French artists tend to be more readily recognisable), but Clarence Lawson Wood was a prolific poster artist and produced a number of excellent images, such as this popular and rather touching painting from 1914. The 'chip of the old block' phrase seems to indicate a father saying goodbye to his son, and the use of the image of a veteran of earlier wars is both poignant and slightly heroic.

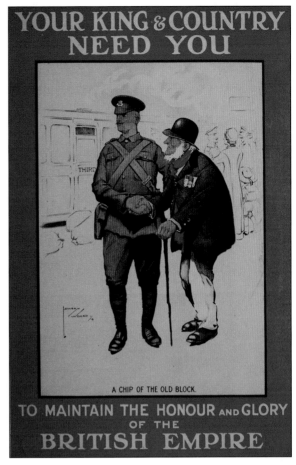

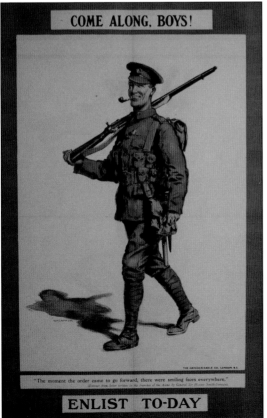

This recruiting poster, produced by the Parliamentary Recruiting Committee in April 1915 and executed by W.H. Caffyn, better known for his fine pen and ink portraiture, shows a smiling Tommy and bears more than a passing resemblance to cartoonist Bert Kent's famous nameless soldier in ''arf a mo', Kaiser'. The sentiment at the bottom – 'there were smiling faces everywhere' – is straight from the pages of one of the boys' comics, for by the time of this poster the gritty reality of war was well understood by the front-line soldier.

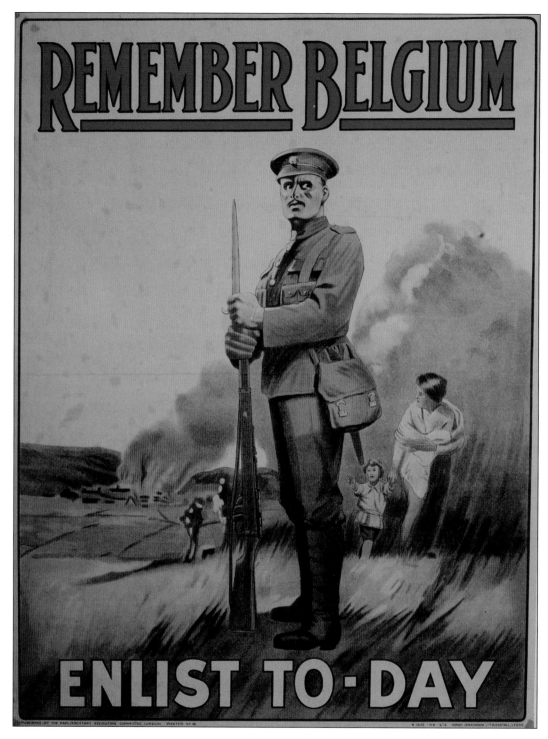

REMEMBER BELGIUM

ENLIST TO-DAY

In 1914 much was made in the British press of the 'Rape of Belgium', with lurid accounts (not all of them false) of German atrocities against innocent civilians. This 1914 poster exhorts the reader to remember what the Germans were capable of, and as the grim-faced British soldier stands guard over the fleeing civilians, the child points to him with a hopeful expression.

A direct appeal to work and fight for 'Our Flag'. The concept of fighting for the flag of one's country is as old as warfare, and still meant a great deal in 1914. By the end of 1916 such overt jingoism had faded and while the soldiers of all sides still fought, the war had become something to endure and be seen through to its logical conclusion. National idealism was no longer a relevant emotion.

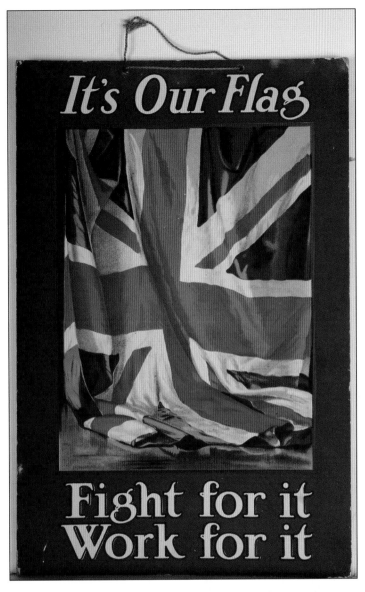

Another of the series of posters by the Parliamentary Recruiting Committee, this is a very simple and graphic image, and possibly the first to depict men going 'over the top' in battle. It is strikingly similar to the famous Boer War photograph of Canadian troops advancing up a hill during the Battle of Colenso.

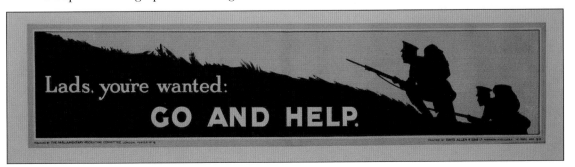

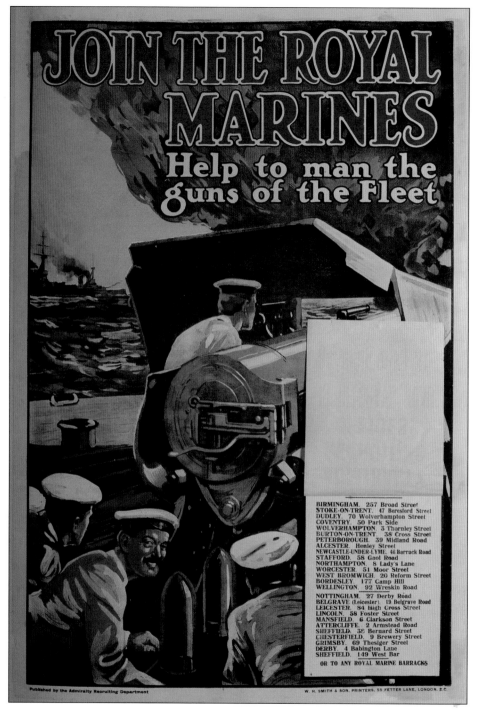

Not many British posters were produced that were directed at getting men to join specific units. Depending where he joined up, a 1914 volunteer was usually allocated to his county regiment, although this changed as the war progressed and casualty levels rose. This Admiralty poster specifically attempts to get men to enlist in the Royal Marine Artillery and helpfully lists all of the recruiting stations, while a slightly manic-looking gunner grins at the viewer.

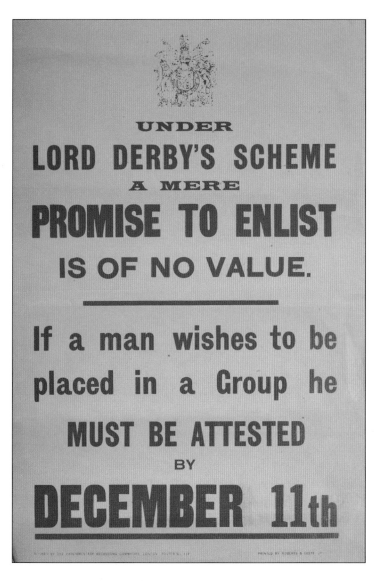

FIGHT FOR FREEDOM WITH THE STRENGTH OF FREE MEN.

Another direct message, this time using no artwork at all, but appealing to the Englishman's sense of pride in being a 'free man', not a medieval serf or slave. The implication, of course, was that failing to fight could once more lead Britons into slavery.

UNDER LORD DERBY'S SCHEME A MERE PROMISE TO ENLIST IS OF NO VALUE.

If a man wishes to be placed in a Group he **MUST BE ATTESTED** BY **DECEMBER 11th**

Lord Derby's Scheme was a half-measure introduced prior to the government accepting that conscription was inevitable. On 11 October 1915 Lord Derby was appointed Director-General of Recruiting and on the 16th he introduced the Derby Scheme for raising large numbers of volunteers. Men aged 18 to 40 could continue to enlist voluntarily, or attest at a recruiting office and return to their civilian occupations, but were obliged to enlist when called up. The War Office stated that voluntary enlistment would cease on 15 December 1915. Men who had registered under the Derby Scheme were classified into married and single, and into twenty-three groups according to their age. The scheme eventually raised 2.4 million men.

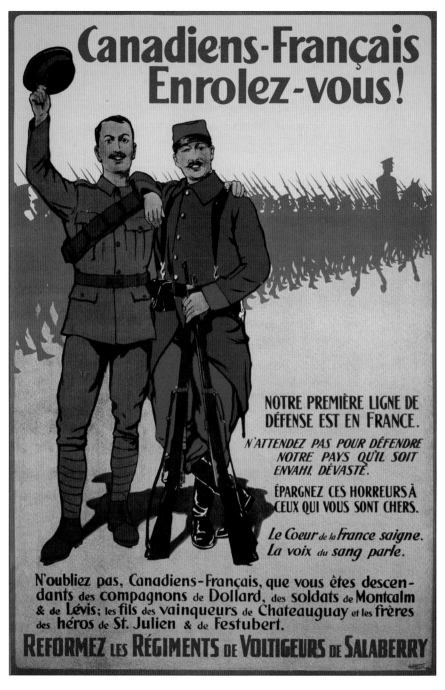

'French Canadians Enlist!' Thousands of French Canadians flocked to join the army in the wake of the German attacks of 1914, and several French language posters were produced. At the outbreak of war the entire Canadian Regular Army numbered only 3,000 men. This poster by Arthur Hider (1875–1952) exhorts French Canadians to enlist to protect their language and institutions, and to recall that they are descended from the soldiers of Generals Montcalm and Levis. Not relying simply on the power of history to draw men into the ranks, the text also makes note of the 'brothers' of the early battles at St Julien and Festubert in 1915.

A very patriotic flag-framed image of Lord Frederick Roberts, who won the Victoria Cross during the Indian Mutiny of 1857. He was largely responsible for defeating the Boers during the Second Boer War (1900–1901), and became the hero of a generation, much as the Duke of Wellington had been a century before. His death at St Omer in France while visiting Indian troops on 14 November 1914 only served to raise him even higher in the nation's regard, and the use of his image here was a subtle one.

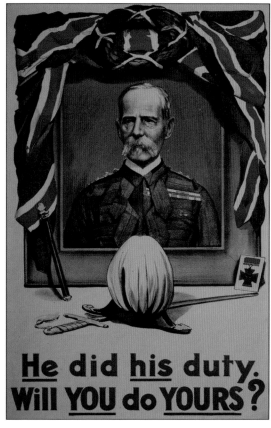

Although it is generally believed that the United States did not join the war until 1918, hostilities were begun with Germany on 6 April 1917 and there were some US troops in France by the time of the Battle of Cambrai (21 November 1917). This poster was one of the first to be printed and its flag-waving soldiers hark back to the age of the American Revolution – hardly a reflection of the reality of the war that the United States was soon to find itself embroiled in.

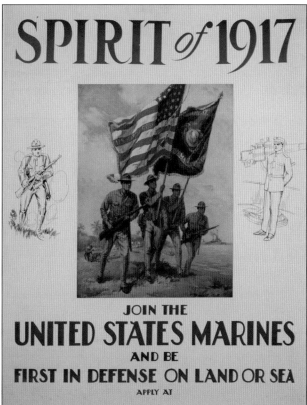

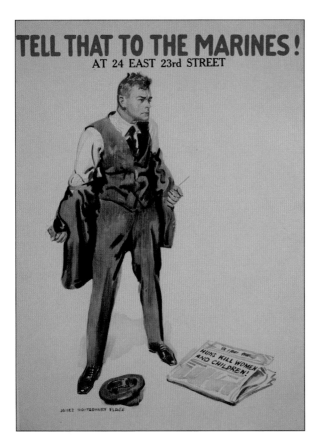

TELL THAT TO THE MARINES!
AT 24 EAST 23rd STREET

HUNS KILL WOMEN AND CHILDREN!

JAMES MONTGOMERY FLAGG

This poster is interesting for several reasons. The artist, James Montgomery Flagg (1877–1960) was the originator of the famous Uncle Sam figure in the hugely popular 'I want you for US army' posters, and he based Sam's face on his own. There is also a covert message in the newspaper headline 'Huns kill women and children', reflecting the popular outrage in the United States over the sinking of the *Lusitania* in May 1915, in which 128 Americans died. This act, indefensible in their eyes, was to set the US on a collision course with Germany.

The title of the poster was an expression first recorded in 1806 – 'You may tell that to the Marines, but I'll be damned if a sailor will believe it' – implying a tale that was just too tall to be believed, and the expression has now passed into modern idiom.

The Marines always prided themselves in being at the forefront of the fighting, and this simple but fine drawing by Adolph Triedler (1886–1981) pays homage to their fighting spirit, and refers to one of the earliest, and largely successful, actions of the American Expeditionary Force at Château-Thierry on 18 July 1918. The soldier is depicted cutting a notch on his rifle butt, indicating one more win for the AEF. During the Great War Triedler specialised in depicting women war workers and was to have a very long and extremely successful career.

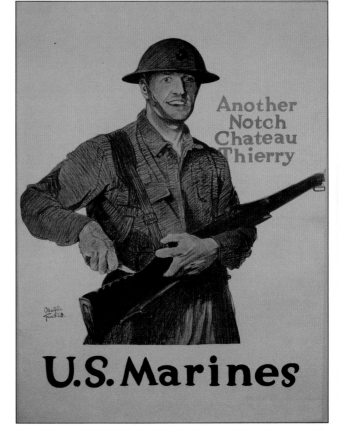

Another Notch Chateau Thierry

U.S. Marines

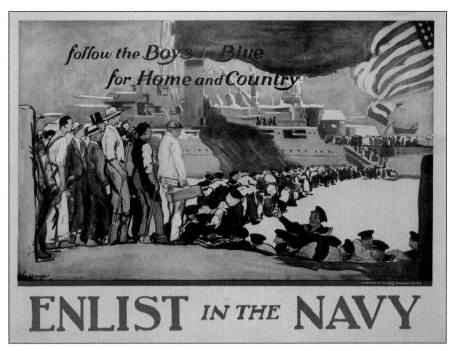

follow the Boys in Blue for Home and Country

ENLIST *IN THE* NAVY

The US Navy was not as heavily involved in the war as their land forces, but the unrestricted U-boat campaign of 1917 was costing many American lives. Between April and June shipping losses amounted to 1.96 million tons and Britain's wheat stocks were reduced to just six weeks' worth. It was quite conceivable that at some stage the Imperial German Navy might well meet head-on with US warships, so navy recruitment was taken seriously. The message of this poster is simple and the slightly cartoon-like image by a little-known artist, George Wright, evokes both a sense of excitement and purpose.

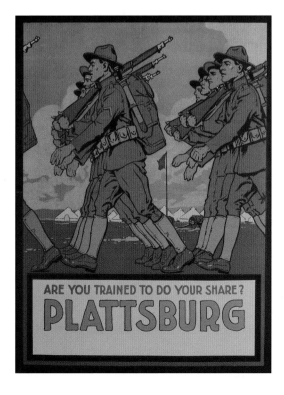

ARE YOU TRAINED TO DO YOUR SHARE?
PLATTSBURG

The army was quick to respond to the demands placed on it, and this poster from 1917 is unusually location-specific, showing the US Army officer training camp at Plattsburg, NY, which had been opened prior to the US entering the war. It was one of several posters produced on behalf of the Military Training Camps Association, and at least two others feature Plattsburg.

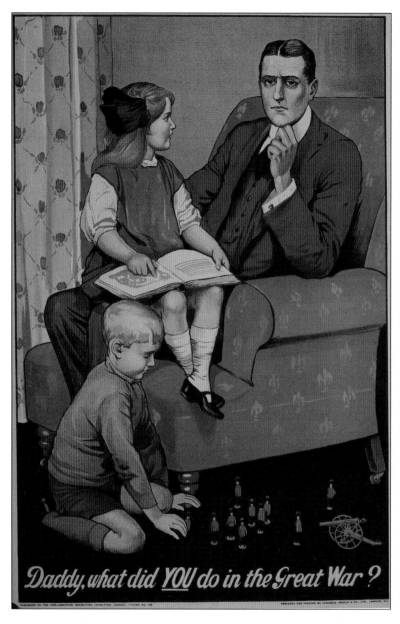

Daddy, what did YOU do in the Great War?

This is arguably one of the most haunting and best known of all the recruitment posters issued during the war. Painted by Augustus Savile Lumley (1878–1949) in late 1914, it is a brilliant example of subtle emotional blackmail. The idea for the image came from the printer Arthur Gunn, who asked his wife that very question one day, having imagined himself as the father in question. The following day he asked Lumley to do a preliminary sketch. Shortly afterwards, Gunn joined the Westminster Volunteers and served throughout the war. Lumley went on to become a very highly respected book illustrator, as well as an artist for *Boy's Own* and *Champion* comics. A very similar version of this poster was reissued in the Second World War.

Chapter 2

Loans and Money

When war was declared in August 1914, the duration of the fighting was not seriously considered by the combatant nations. The belief that it would be a short, sharp conflict was a universal one, although a few lone voices warned of the possibility of a war that would last for years. Few heeded them. When the lines stagnated in the winter of 1914 it became gradually apparent that there was not to be a decisive breakthrough on either side. Of all of the industrialised nations, Germany had the strongest economy, with the largest manufacturing output, second in the world only to that of the United States. Despite this, the German and Austrian war economy was severely disadvantaged by its reliance on its export trade with the rest of the world, and this trade had collapsed during the fighting. Most of what Germany needed to wage war had to be imported. She had no stocks of rubber, cotton or ores and few chemicals, and was largely excluded from trading on the international financial markets.

As the economy slowed, the German government attempted to increase its income through public war bonds or *Kriegsanleihe*. Nine issues were made during the war, boosted by the extensive use of poster propaganda. This worked initially, and over the course of the war some 100 billion marks were raised, but as shortages of food hit home, so public confidence in the economy and the government faltered and the domestic crisis worsened. The problems were exacerbated by the conscription of so many farmers and land workers into the army, and the British naval blockade. So short of food was Germany that the winter of 1916/1917 was known as the 'turnip winter', as that vegetable was almost all that was freely available. Some 750,000 Germans died of malnutrition during the war, and by 1918 the government was unable to repay the interest on the bonds.

In 1914 Britain had a flourishing economy, with strong export trade; while this was much reduced during the war, it was still possible for Britain to continue trading. Most of what was required was available from countries friendly to the Allied cause – beef from Argentina, ores from South America,

rubber from Malaysia. However, the war economy and the need to fund an army of over 5 million men placed an unsustainable burden on the economy, so a system of offering guaranteed short-term public loans that had originated during the Napoleonic wars was revived in November 1914. These war loans proved very successful, partly because of public confidence. The British public, unlike in Germany, had greater faith in their government and had suffered fewer privations as a result of shortages; they also believed that the Allies would eventually win the war. Although £2.75 billion was raised by the war loans system, the national debt increased from £650 million in 1914 to £7.4 billion by 1919, much of which was owed to the United States. To give some indication of how huge the debt was, the outstanding amount of war bonds still to be repaid stands at £31,939,000 (as of 2012).

In common with most industrialised nations before 1914, the French economy was also buoyant. However, the German-occupied territories contained 58 per cent of the steel and 48 per cent of the coal that France required for its war production. This placed France in a financially impossible position, as much of the materiel that was needed had to be imported and paid for in hard currency, and by late 1916 she also had an army of 6 million men to be paid for. Ever more money was required to meet the mounting national debt, so the government began to offer war loans similar in form to those in Britain, although generally of a longer-term nature. They too used a striking series of posters aimed at persuading the public to invest in the war as an act of patriotism. The problems in repaying them were, of course, the same as those faced by all the other belligerent countries, in that eventually the cost of repayments spiralled out of control. Most of the loans were repaid at only 25 per cent of their face value as inflation and changes of political policy eroded their worth.

The United States was probably the most successful country in regards to financing their war effort, aided, of course, by having the largest world economy. In early 1917 the American government began issuing Liberty Bonds to raise capital, and this policy was aided by a very aggressive advertising campaign in conjunction with the Committee on Public Information to ensure the bonds became popular with the public. However, as with the campaigns in other countries, the money raised ($21.5 billion dollars) was mostly from financial institutions and corporations, and postwar examination of the War Bond Campaign showed that it actually attracted very little public support. In fact, this proved to be true for all of the countries that attempted to raise money from the public, for despite the very broad range of posters that were produced, which incorporated elements of propaganda, coercion and emotional blackmail, they did not achieve the desired result. However, they did leave behind an extraordinary legacy of art for future generations.

'For France give your gold. Gold fights for victory.' Half of French war spending was covered by loans. This enabled the government not to raise taxes, despite the mounting demand for credit. Posters became an essential means for this financial effort. Abel Faivre was one of the few French artists who did not fill the entire background but let the main elements stand out. His simple messages derived from his experience as a caricaturist. For the first French National Defence Loan launched in November 1915, he turned a catchphrase into a literal meaning. The complex nature of the war effort is reduced to its unique goal: defeating the German Army.

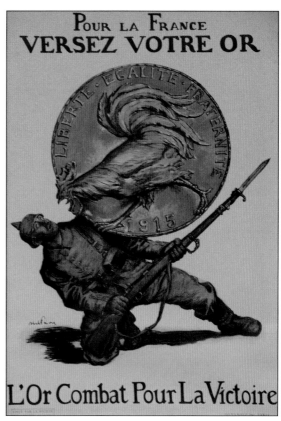

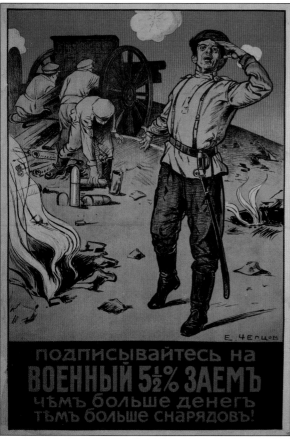

'Subscribe to the 5.5% war loan. The more money there is, the more munitions there will be!' Though the Russian forces were often considered to rely solely on sheer numbers, the country's industrial and military power was growing fast by 1910. Artillerymen were particularly proud of their artillery fuses, a technological marvel of the time. However, the munitions crisis was especially severe in Russia from 1915 onwards. This battle scene, with the exceptional smouldering shell craters, gives an intense sense of emergency that is reinforced by the direct gaze of the soldier.

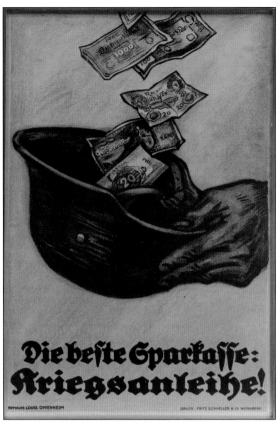

'The best savings bank: the war loan!' Here Louis Oppenheim has created a visual short-cut by having bank notes going directly to the army, once again symbolised by a steel helmet. At a time when getting change was difficult, the wording on the poster was all the more reassuring for the population. As it turned out, the war loans were often for a five-year period. By 1923 the German state couldn't reimburse them when they expired. It resorted to printing new bank notes but this caused massive inflation. By November 1923 one dollar was worth 12 thousand billion German Marks. Small stockholders were ruined.

The war was to prove more costly than the British government could possibly have imagined and alternative sources of funding were soon needed. War Bonds were a debt security issued by the government, originally conceived under the term 'Consols' as a means of helping refinance the debts incurred in the Napoleonic wars. They helped to generate vast sums of money during the war years – £1.54 billion in the case of the First and Second War Loans. The line-up of guns reinforces the link between funding and manufacture.

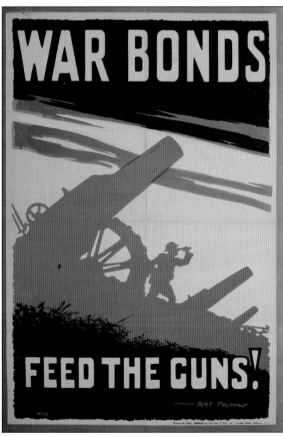

This poster shows a particularly aggressive link between purchasing war bonds and the use of high explosive. Perhaps at first sight rather obscure, it is in fact an extremely clever message, showing that the purchase of bonds, and the money generated, directly assisted the fighting at the front. In the public's mind, bonds therefore equated to the purchase of raw materials, and the manufacture of shells, ammunitions and bombs. Such an image actually has a very direct appeal and avoids wordy explanations.

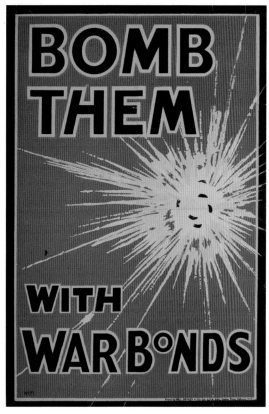

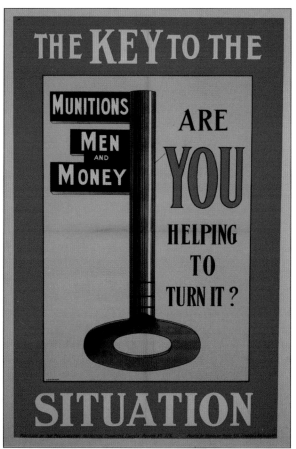

Here the key symbol is used to unlock the three main elements for an efficient wartime manufacturing economy: munitions, men and money. However, unlike the straightforward demands of a recruiting poster, this was actually a somewhat complex appeal that stressed not only the need for a suitable workforce but also for financial investment in industry, presumably by means of war bonds or savings stamps. Later posters were more focused and direct in their appeal.

51

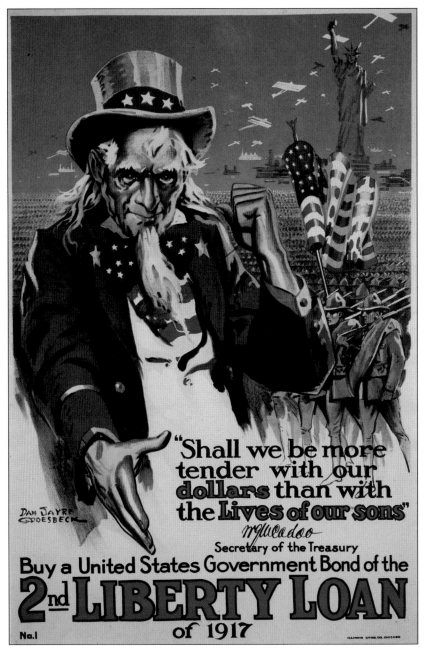

This image depicts Uncle Sam, who first became a public figure when illustrated in *Leslie's Weekly* in July 1916, although he had originally evolved as a character in 1835. Duplicating the famous pointing finger of the Kitchener posters, Uncle Sam was initially used as a recruitment aid, some 4 million posters being distributed in two years. The figure was painted by Dan Sayre Groesbeck (1878–1950), a self-educated Californian artist, who was to have an extraordinarily prolific output of paintings, drawings and prints. Although he is probably better remembered today for his vast panoramas of early American settler life, of greater significance was his pioneering use of story-boards for illustrating film scenes and for building up character profiles.

The pursuit of liberty was a favourite American political and social theme. The Statue of Liberty, designed by Frédéric Bartholdi, was inaugurated in October 1886 and represents Liberty enlightening the world ('La Liberté éclairant le monde'). It was, and still is, a potent symbol of American freedom and has been represented in countless images. In this early 1917 liberty bond image, the now familiar accusatory pointing finger is allied to a rather fearsome glare to put across the message that bonds equate to freedom.

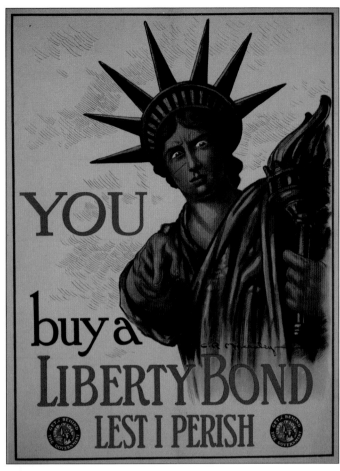

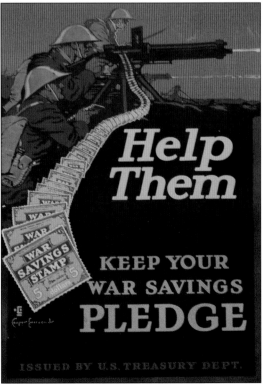

This War Savings work by Caspar Emerson (1878–1948) uses a clever visual allegory by replacing the belts of machine-gun ammunition by war savings stamps. The message from the image is unequivocal: buying stamps has a direct link with keeping the guns firing, and it is both simple and effective. This rather cartoon-like work is unusual for Emerson, who was best known for his fine dock and harbour views, and ships and whaling scenes. Less well known is that he was the great-nephew of Roald Amundsen, the polar explorer, in honour of whom he changed his name in 1943 to Amundsen.

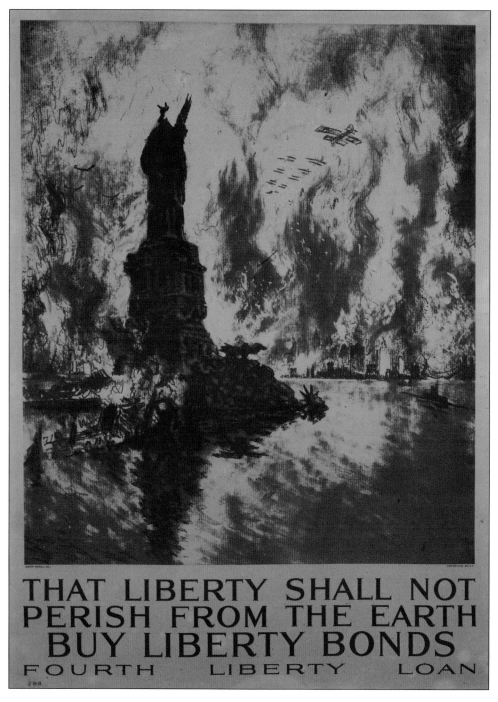

THAT LIBERTY SHALL NOT
PERISH FROM THE EARTH
BUY LIBERTY BONDS
FOURTH LIBERTY LOAN

This apocalyptic image from 1918 shows New York City harbour in flames during an attack by German battleships and bombers. It was executed by Joseph Pennell (1857–1926), an American who moved to London in the late 1880s, where he taught at the Royal College of Art and the Slade School of Art. He returned to the United States in 1917 and undertook several war poster commissions. This particular work is interesting for it is one of the first illustrations to recognise the potential of aerial bombing.

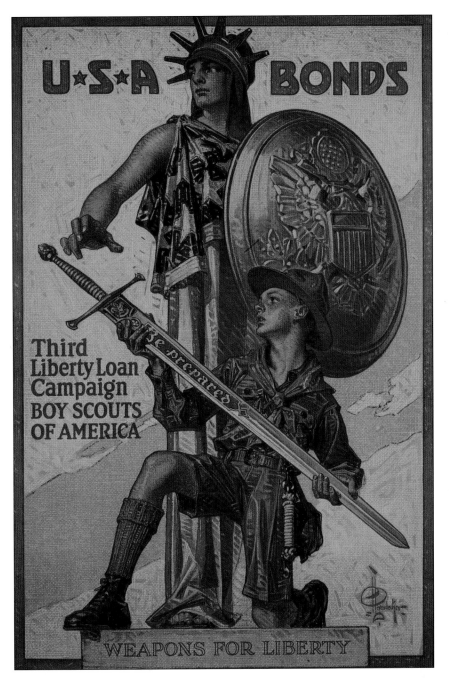

One of the classic poster images of the Great War, this shows a scout on bended knee offering to Lady Liberty her sword, on the blade of which is the scout's motto 'Be prepared'. It was painted by Joseph C. Leyendecker (1874–1951), who was born in Montabaur, Germany. Much of Leyendecker's work was for the cover of the *Saturday Evening Post*, the most prestigious magazine of the period (the concept of Mothers' Day came about as a result of a cover he painted in May 1914). His style is still widely copied today and this poster is still in print. The Boy Scout posters produced by Leyendecker and others helped to raise $350 million worth of donations between 1917 and 1919.

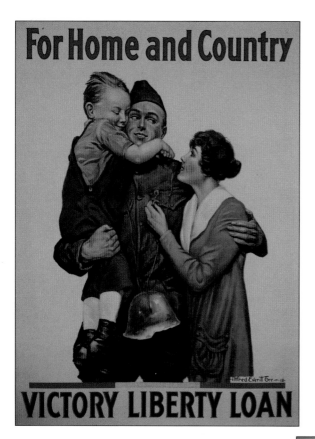

For Home and Country

VICTORY LIBERTY LOAN

In contrast to the classical posing of the figures in the previous image, this very homely painting by Alfred Everett Smith (1863–1955) shows a doughboy father, with bullet-holed German helmet, safe in the arms of his loving family. His wife proudly holds the victory medal pinned on his chest. The implication of the poster was that there was a direct link between raising money and the speed with which the men could be brought home. The Victory Liberty Loan programme was instigated on 21 April 1919.

Even after almost a century, daylight saving is still a contentious issue. Originally conceived in 1895, it was adopted by Britain on 21 May 1916 and has remained in use ever since. Introduced not only as a means of increasing production, the use of extra daylight was estimated to have saved £8 million in electricity production during the war. In the US it was not to become law until March 1918 and it was so thoroughly disliked that after the war it was left to individual states to decide on whether or not it should be retained and the Uniform Time Act did not come into force until 1966.

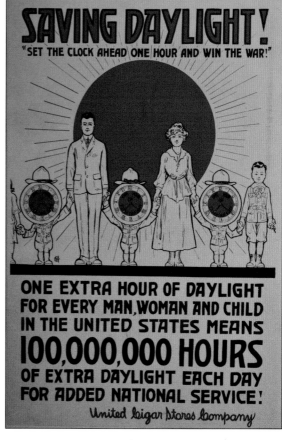

SAVING DAYLIGHT!
"SET THE CLOCK AHEAD ONE HOUR AND WIN THE WAR!"

ONE EXTRA HOUR OF DAYLIGHT FOR EVERY MAN, WOMAN AND CHILD IN THE UNITED STATES MEANS 100,000,000 HOURS OF EXTRA DAYLIGHT EACH DAY FOR ADDED NATIONAL SERVICE!
United Cigar Stores Company

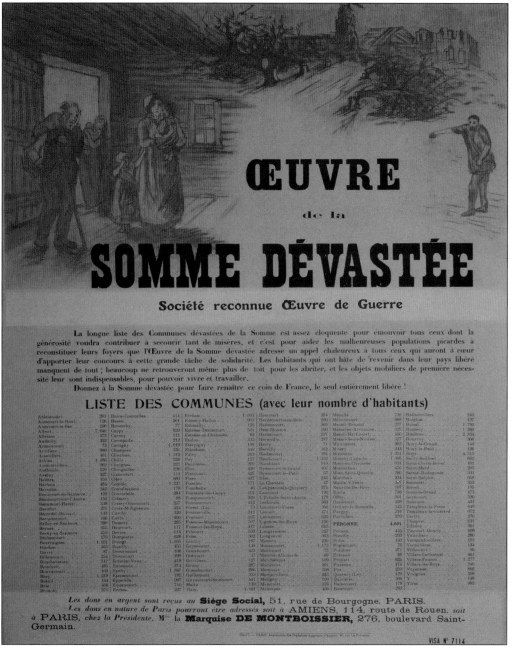

'Charity for the devastated Somme.' This charity was set up in 1917 when the Germans retreated to the Hindenburg Line and civilians immediately returned to their home villages. The methodically felled trees in front of Albert's famous leaning Virgin, the lunar landscapes that need sowing and the absence of any but temporary wood lodgings only hint at the difficulties. By listing the destroyed villages and their populations, the charity encouraged donations in cash and in kind. The example of the village of Maurepas is striking: the first donations to arrive here after the war were a bicycle and a cow. For months the inhabitants had to live in abandoned bunkers and crumbling cellars. A cow provided vital milk, butter and cheese, while a bicycle allowed access to nearby markets.

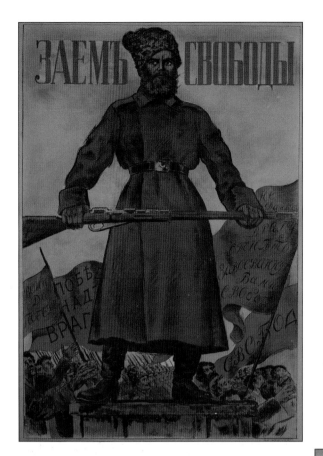

'The loan of liberty.' (The flags, from left to right, read 'War until victory'; 'Victory over the enemy'; 'Do not let the enemy take the liberty you have conquered'; and 'Liberty'.) With the first Russian Revolution in February 1917, the question of pursuing or stopping the war became central. The provisional government led by Kerensky was determined to honour its alliances. This poster therefore shows a perfectly organised army in harmony with the people. The figure of the soldier, in his protective stance, defends the nation's newly earned freedom. However, military set-backs and the November Revolution would lead to a change of policy: Lenin and the Bolsheviks would sue for a separate peace ultimately signed in Brest-Litovsk in 1918.

This very stark poster by H. Devitt Welsh (1888–1942) is of a very different form from the many heroic types that were still being produced. It is no small coincidence that the image is strongly representative of the three crosses of the Calvary, and the message is one of personal sacrifice for a greater cause. It was issued by the Committee on Public Information, Division of Pictorial Publicity, in 1917.

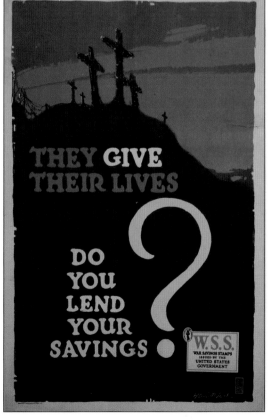

This gloriously patriotic piece is in direct contrast to the previous illustration. It was created by Sidney Riesenberg (1885–1932), a Chicago-born illustrator and painter who moved to New York, where he achieved considerable success producing covers and illustrations for popular magazines of the day, such as *Harper's*, *Collier's* and the *Saturday Evening Post*. Like Dan Groesbeck, Riesenberg is best remembered today for his mainly western-themed paintings, and some of his original works have recently fetched record prices. His two most famous posters were this one and the much-reproduced 'Remember the Flag of Liberty'.

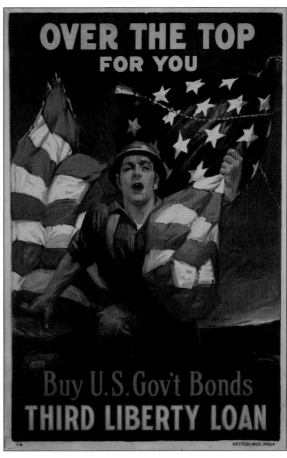

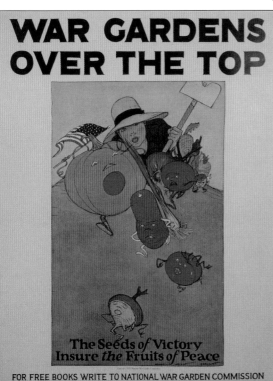

This charming poster uses a rather wry take on the 'over the top' message which is quite different from other interpretations. The artist was the wonderfully named Maginel Wright Enright Barney (1881–1966), who was the sister of the famous architect Frank Lloyd Wright. She became a very well-known children's book illustrator, as well as a prolific magazine artist. The charging vegetables are a clever substitute for the attacking soldiers usually found in wartime posters, and were aimed at encouraging more people to grow their own fruit and vegetables. This poster was not released until 1919, after the war, when food was still in short supply.

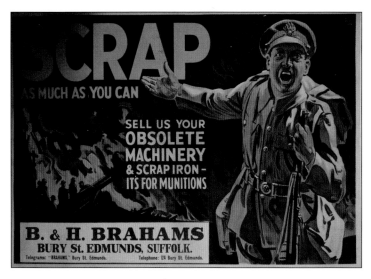

Finding sufficient raw materials to keep war production going was difficult, particularly as the U-boat campaign began to take a heavy toll on Allied shipping. This unusual and particularly striking image depicts a British soldier calling to the viewers to give as much scrap metal as they could. It is unusual in having the name and contact details of a metal dealer, Brahams, on the poster. Most information posters were more general in content, and whether this was sponsored by Brahams is unknown.

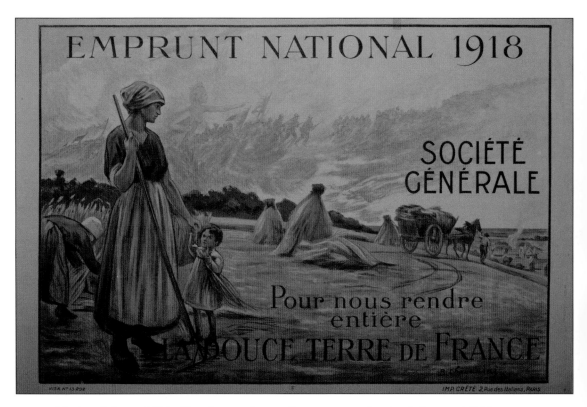

'National loan 1918. To give us back all our sweet land of France.' This scene simultaneously reflects a pastoral tradition and a leitmotiv of military painting. France was still a rural nation during the Great War. In fact, it was not until 1929 that the urban population topped the rural one. The harvest was therefore an explicit sign of plenty, and these women, replacing the male farmers, links this imagery to the war context. The troops in the sky, led by the French Marianne allegory, echo the pictorial symbols of historical and military paintings recalling the Napoleonic era.

Canada did not produce as many posters during the war as other Allied countries, but those that were issued tended to be of high quality and used imagery very cleverly. This one, reproducing in art form the famous photograph by the French official artist Tournassoud, shows three toiling French fieldworkers. It is a finely executed and thought-provoking image showing that ordinary life had to continue in the absence of both men and draught-horses. The image of women pulling a plough would have been quite shocking to the generation of the Great War, with its subtle message that in order to help win the war, the women of France were prepared to be beasts of burden.

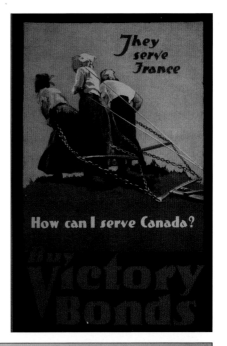

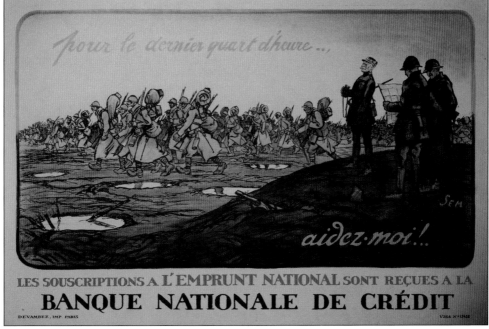

'For the last quarter of an hour ... Help me. Subscriptions to the National Loan can be taken at the National Bank of Credit.' Sem (also known as Georges Goursat) had made a name for himself, principally among socialites, as a portraitist. For this 1918 war loan poster, he depicts General Foch reviewing his troops going off to battle. The direct appeal of the Commander-in-Chief of the Allied armies is almost a pressing order. The artist uses the fact that military leaders were then revered authorities. Their prewar prestige grew with the conflict, often overshadowing political leaders in patriotic productions (such as tableware, postcards and statuettes). The figure of Foch rapidly became omnipresent.

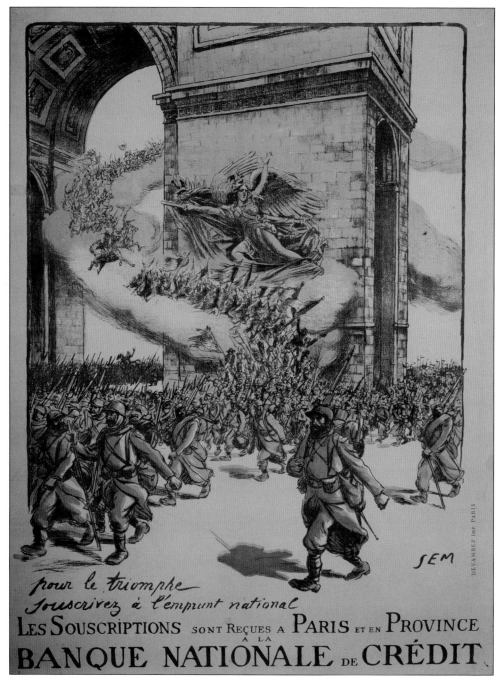

'For triumph. Subscribe to the national loan. Subscriptions can be made in Paris and the provinces. National bank of credit.' Many artists used France's long military history to make the Poilu the last link in a glorious tradition. References to Napoleonic soldiers are extremely frequent. In this case, the men of the Great War are literally descendants of revolutionary soldiers: the Arch of Triumph pillar is illustrated with Rude's sculpture of French Revolutionary volunteers. The artist Sem anticipates the renewed triumph of French forces over aggressive foes and represents the men parading past the Arch of Triumph.

Chapter 3

The Soldier

T he soldier was the central figure of most war posters. This representation was never static and evolved over the course of the war. Initial posters echoed the enthusiastic images propagated by the press or in cheap media such as postcards. However, with time and ever-mounting casualties, a more subtle image of the soldier started to appear: certain artists were also soldiers and had experienced at first hand the discrepancy between the war they had imagined and the reality of combat. A more restrained imagery began to appear, centred on the courage needed to hold the line without necessarily attacking at all costs. The question of the wounded also raised the issue of what could be shown and what might be considered demoralising or too gruesome. New representations appeared without completely erasing the former ones. With victory in sight, there was a return in the Allied countries to the earlier images, renewing the dynamic, even aggressive, vision of the early war period.

Nevertheless, some elements were constant. The soldier was always a reassuring figure; he represented virility and was regularly portrayed as being admired by women. More than an individual, the soldier stood for the whole country. He was closely associated with the earth element, not just because he fought in the trenches but because, in the still predominantly agricultural societies of the time, this evoked the eternal values of land and country. It is striking how opposing countries could use almost identical imagery: the soldier as a symbol of a united nation (which had put aside any political or social differences) was therefore also an allegory of each country's long glorious history.

For this reason, traditional imagery of mythical figures and allegories flourished. Medieval knights and Greek warriors were commonly represented, a phenomenon that was not without some nostalgia. By using such models one could become part of an epic tale that absorbed fear and suffering into a greater meaning. A sub-category of these heraldic elements

is the use of animals to represent the country, and at the same time values such as courage and force.

Of course, the reality of a modern war did not escape the public or poster artists. The lone warrior became an increasingly mechanised and even collective entity. Technological superiority was used as shorthand for certain victory in the near future. Although the prewar arms race had seen the development of constantly bigger armoured battleships, these Dreadnoughts did not have a determining impact, and submarines became the main naval weapon represented in posters. The Great War was also exceptional in the sense that new weapons were created during the conflict itself: the massive dimensions of the tank assured its maximum visual impact and therefore great pictorial success.

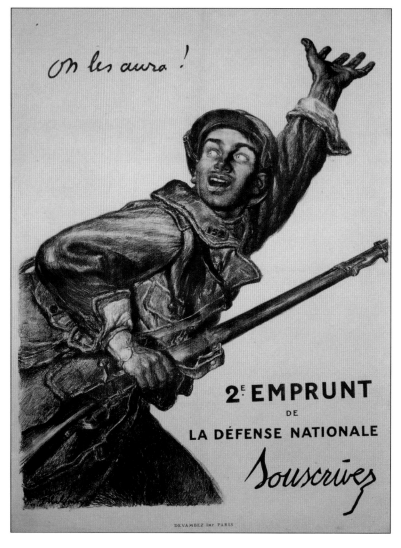

'We'll get them! 2nd national defence loan. Subscribe.' This is probably the most famous French poster and some 200,000 copies graced the nation's walls. Its force resides in the soldier's gesture imitating Rude's sculpture on the Arch of Triumph in Paris. Abel Faivre transposes this reference to national history on to his model, Jean-Baptiste Decobecq, a private from the occupied city of Valenciennes, and thus a symbol of the country in peril. The first draft portrayed a furious face but the final version insisted on the enthusiasm that overcomes everything. The words 'On les aura' were also used in General Petain's famous order dated 10 April 1916 during the battle of Verdun.

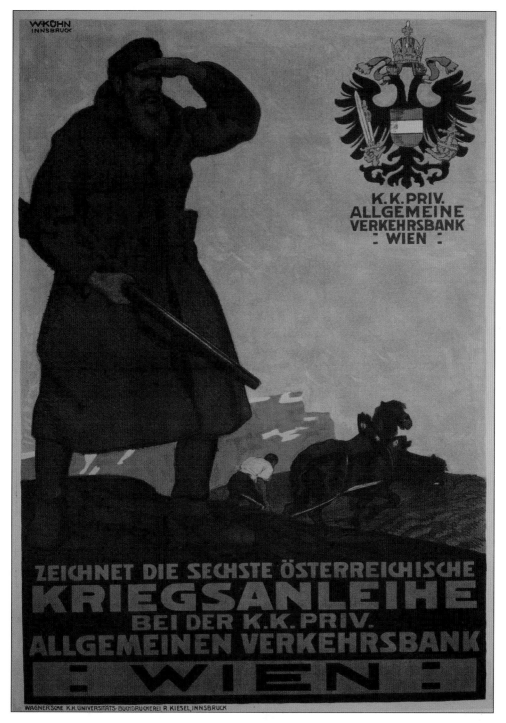

'Subscribe to the sixth Austrian war loan by the Royal and Imperial Private General Commerce Bank. Vienna.' This Austrian poster portrays an important component of masculine identity: men were responsible for the security of the community whatever their age. The bearded, and therefore virile, man has not hesitated to take up arms to fend off the (unseen) enemy. In the multicultural Austria-Hungary, such simple illustrations could reach out to all its members.

SPENDET GABEN FÜR DIE KOLONIAL-KRIEGERSPENDE

'Give your donations to the Colonial Warrior Charity.' Two million Africans fought in or worked for the war. Several hundred thousand fought in Europe as well as in Africa, where most German colonies were quickly overrun by superior Allied troops backed by a powerful navy. However, Paul von Lettow-Vorbeck led a guerrilla war in today's Tanzania until 25 November 1918. The figure of the German colonial soldier, here seen proudly waving the Imperial flag, became a symbol of obstinate resistance. The contribution of Africans (on all sides) raised lasting questions of rights and self-determination in the colonies.

'Help us win! Subscribe to the war loan.' Erler's work for the sixth war loan in 1917 is the first German representation of the soldier at the front. It was massively distributed and contributed to creating a new image of the modern soldier. The steel helmet would become the symbol of the war which literally forged a new iron fighter: Ernst Jünger in *Storm of Steel* describes how the line of the new helmet hardened the look of his men as they entered the inferno of the Somme. This imagery would be systematically used when role-model figures on posters became more generalised in the 1930s and 1940s.

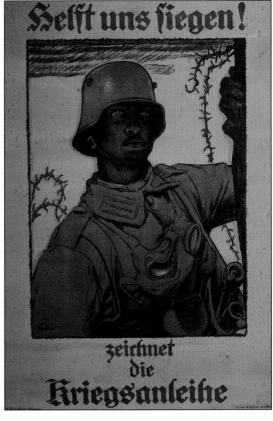

Helft uns siegen!

zeichnet die Kriegsanleihe

This somewhat jollier painting depicts a Canadian Scottish soldier exhorting the public to help the war effort by buying bonds. Canadians, particularly those of Scots and Irish descent, were immensely proud of their ancestral roots, and this is a direct appeal at those who would have identified with the kilted figure. Canada had been in the war since 1914, and by the armistice had paid a high price for her involvement, losing 67,000 killed and 150,000 wounded.

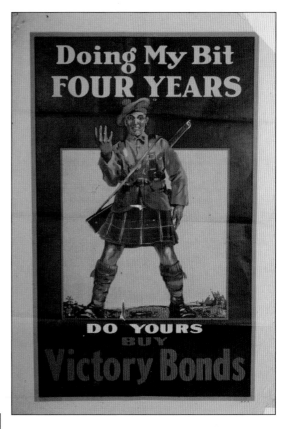

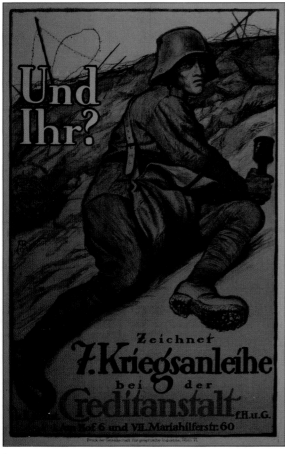

'And you? Subscribe to the seventh war loan at the Credit Centre.' This Austro-Hungarian poster represents a typical stormtrooper. The hand grenade was more practical for fighting in the trenches and for neutralising dug-outs. Stormtroopers were lightly equipped but heavily armed to allow rapid movement. The initiative permitted to them on the battlefield was a radical departure from the rigid adherence to orders of the middle of the war. Introduced as a way of countering the Allies' growing technological superiority, this fighting technique re-established the individual's will as a decisive element of victory. The figure of the warrior was central to war propaganda and to Remembrance.

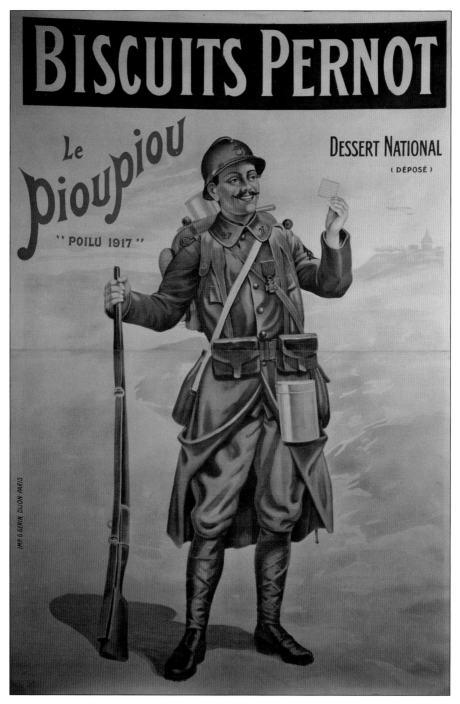

'Pernot biscuits. National dessert. The piou piou "Poilu 1917".' (Piou piou was an affectionate nickname for the French soldier in 1914, while poilu was a nickname extolling the soldier's virility.) The typical French soldier is represented here, wearing the blue uniform and carrying the standard equipment. The Croix de Guerre (the French equivalent of a Mention in Dispatches) and the virile moustache contribute to a highly positive image. Representing a soldier quickly became an excellent advertisement tactic for a great variety of products.

The YMCA (Young Men's Christian Association) was formed in 1856 and provided vital aid to soldiers during the American Civil War. In 1917, when the United States joined the war, it fielded some 35,000 volunteer workers to provide 'spiritual and social support' for the troops, and they provided 90 per cent of all welfare for the US Expeditionary Force in France, operating from twenty-six bases; it has been calculated that some 2 million US soldiers made use of their services. During 1917–1918 the YMCA lost six men and two women as a result of enemy action and earned 319 decorations. What is less well known is that the YMCA also provided aid and comfort to prisoners held in Allied camps.

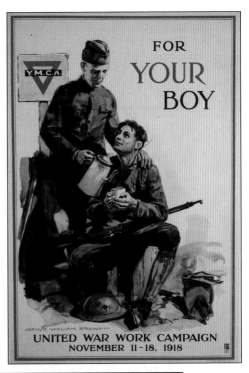

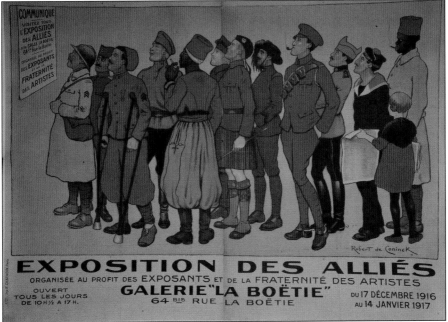

'Exhibition of the Allies organised for the profit of the exhibitors and the artists' fraternity.' The 'mise en abyme' or self-reflection of this poster was not a novelty of the war. Many posters for films or plays had spectators represented on them. In this case, it reflects the military power of France's numerous Allies. In this case, having different nationalities present was also in part a way to invite larger audiences: the cultural scene had been hard-hit by the war. Theatres did not reopen until 1915 and artists were regularly harassed for not being at the front.

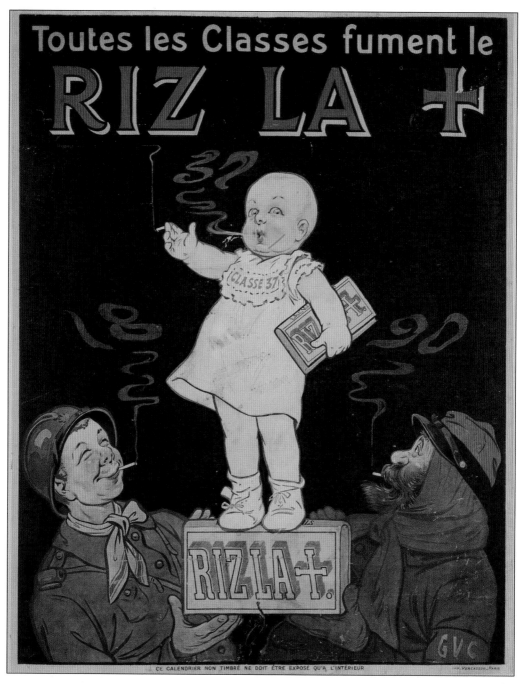

'Every class smokes the Riz la Croix.' This advertisement for cigarette paper can be dated to 1917. With conscription, every young inductee would be given as his enlistment-class number the year he turned twenty. These classes appear in the smoke. The old Territorial would have been out of the army if it were not for the war, and 19-year-old soldiers were only called up in advance to compensate for the war's losses. Simultaneously, propaganda encouraged pro-children policies: babies were drawn ready to fight. Despite the spring mutinies, the French population could not imagine not fighting on until victory.

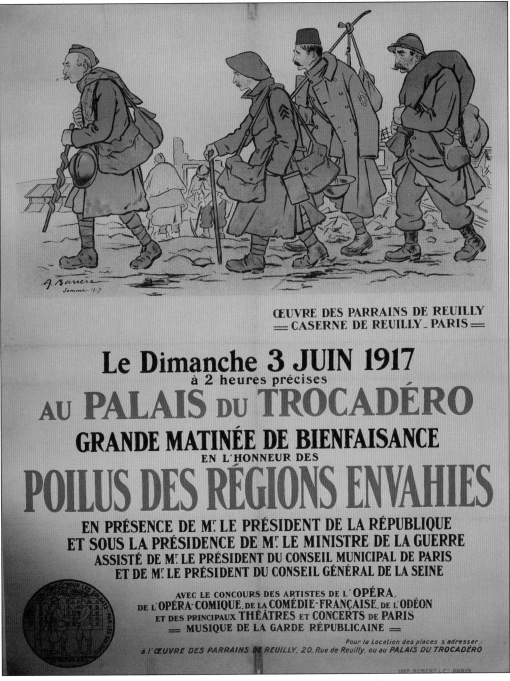

'Sunday 3 June 1917 at 2 o'clock sharp at the Trocadero Palace Grand Charity matinée in honour of the soldiers of the invaded regions.' Adrian Barrère was an official French war artist sent to the front to show the work of the Medical Corps, and his work is more realistic than most. He depicted everyday life scenes of soldiers, be they infantrymen, chasseurs or colonial troops. The stripes on the two central characters' arms indicate that each has been fighting for over two years. The artist also includes details such as the hand-carved cane on the left. The tired looks nevertheless do not question the determination of these men.

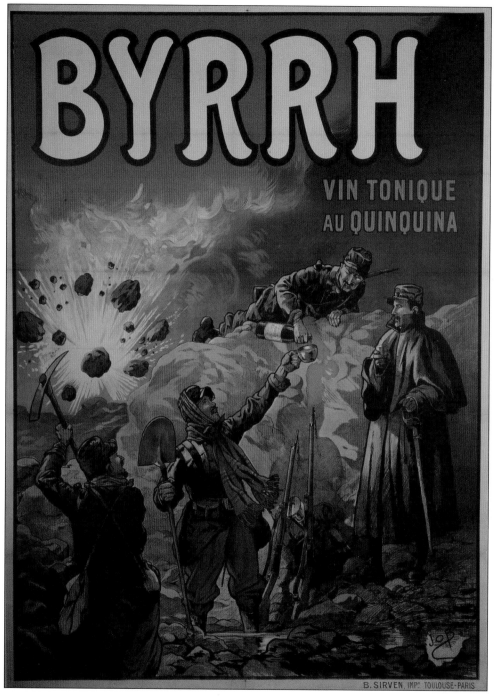

'Byrrh. Tonic wine with cinchona.' Jacques Onfroy de Bréville, better known as Job, had been in the French Army before becoming an artist, caricaturist and illustrator for children's books. He was especially gifted at drawing French history and uniforms. Thus many equipment details are painstakingly reproduced. However, the unrealistic position of the soldier outside the trench, despite being designed to better fill the picture, would have annoyed front-line soldiers. Even years after the war, veterans would bristle at anything considered not exactly correct.

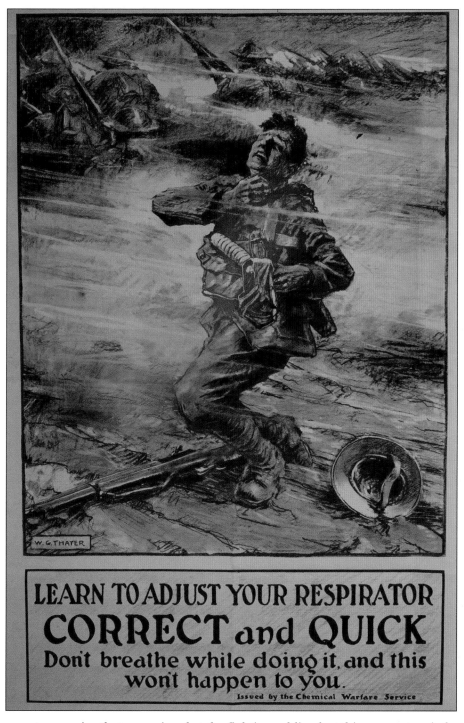

LEARN TO ADJUST YOUR RESPIRATOR
CORRECT and QUICK
Don't breathe while doing it, and this
won't happen to you.
Issued by the Chemical Warfare Service

Few posters survive that were aimed at the fighting soldier, but this one, put up in large numbers in American training camps in France and Flanders, is self-explanatory. It was drawn by Lieutenant W.G. Thayer of the US Army's Gas Defence Division, which was established in June 1918, and shows the potential fate of failing to wear a gas mask. Gas attack was a constant threat during the war and such messages were taken seriously as the result of gas inhalation was terrible.

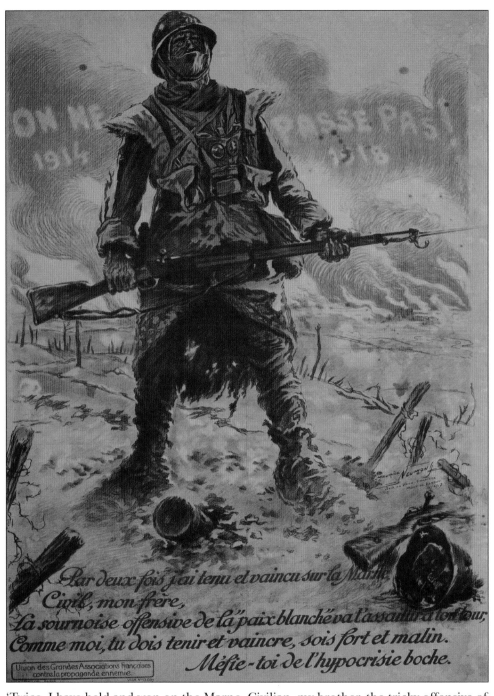

'Twice, I have held and won on the Marne. Civilian, my brother, the tricky offensive of "Peace without victory" will also attack you. Like me, you must hold and win, be strong and clever. Beware the Boche hypocrisy.' Years of bloody stalemate had made enthusiastic messages seem out of touch. With a French average death-toll of more than 850 men a day, courage was no longer the ability to take the offensive but became also a stubborn, stoic resistance symbolised by Verdun and the Marne. The haggard soldier barring the way against the enemy would become in the postwar years a much-used symbol in France.

'The Hias. A field-grey theatre play.' The Hias (a derogatory abbreviation of Matthias) was a Bavarian patriotic play produced by soldiers and officers. It glorified comradeship and war as an adventure through the main character of the dumb batman. Whereas another poster of the play shows a German attack, this poster has the Hias in question positioned for a last stand. Alone against the (unseen) enemy symbolised by the bayonet, using his empty rifle as a club or a sword, he resembles a heroic defender in the wall's breach. Such an image would have been immediately understandable by soldiers and civilians alike: the Germans were defending their homeland.

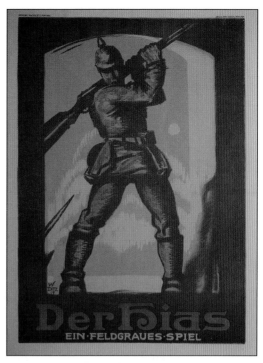

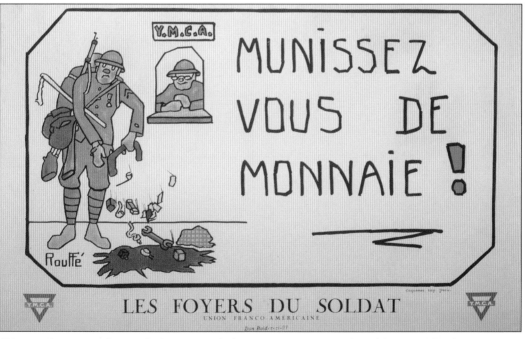

'Please give exact change.' This poster belongs to a series produced by Rouffé, whose posters have a cartoon touch to them as the artist was known for his humorous works in the illustrated newspaper *La Baïonnette* ('The Bayonet'). These posters were designed to influence the conduct of resting soldiers at YMCA homes. It was probably more realistic to ask for the resting troops' cooperation through a light-hearted message than to issue yet another formal order. By the end of the war many non-strategic interactions between the hierarchy and the men had been made less strict.

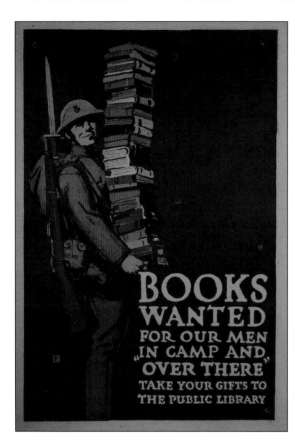

As this grinning soldier makes clear, soldiers were not only fighters. The American Army deemed books so important for morale that they had official travelling libraries that could be carried as a backpack by an individual soldier. Libraries were set up in camps, hospitals, prisoner of war camps and even on board ships. Universities were set up in France to enable the soldiers to learn a trade in preparation for returning to civilian life. According to the American Library Association, over 7 million books were given out.

'Good books, good comrades. You, too, give often and of all kinds: a good book is always free here!' The troops often had long periods of waiting, and books provided a way of keeping these men calm and healthily occupied, as shown here. It was also a way of mentally escaping from the war, of reconnecting with prewar cultural practices or simply of understanding the ongoing war: in Germany alone well over 10,000 essays were written about the war as it was taking place. Among other contributions, 250,000 books were given by the German Librarian Association and 100,000 other books by the Association for Promoting Popular Culture to hospitals.

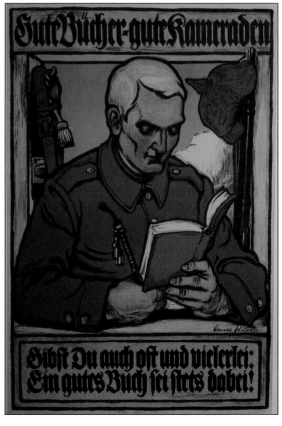

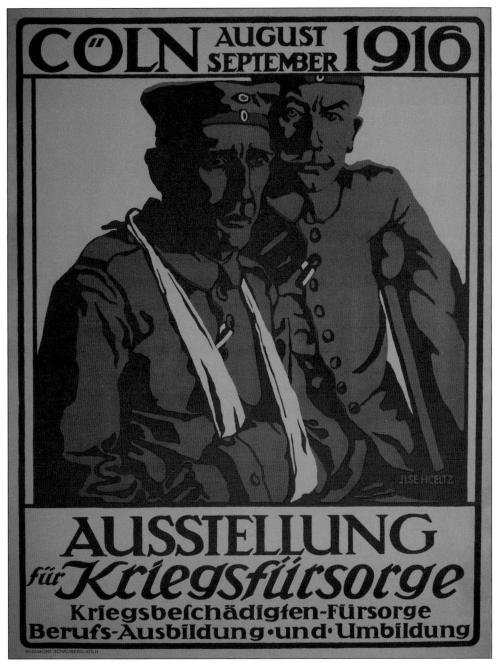

'Cologne August September 1916. Exhibition for war welfare. Aid for war wounded. Apprenticeships and vocational training.' The soldiers' sacrifice was central to the mobilisation of the home front. Images designed to cause feelings of guilt would cut short any debate: they dramatised the hardships of the front in order to minimise the civilians' conditions. The sling, the crutch and the bandages were the typical representations of the wounded that eliminated cruder and potentially unbearable visions of war. The rhetoric of the unique, incomparable experience of the soldiers would continue after the war: many ideologies, not least the Italian Fascist and German Nazi visions, advocated a militarised country.

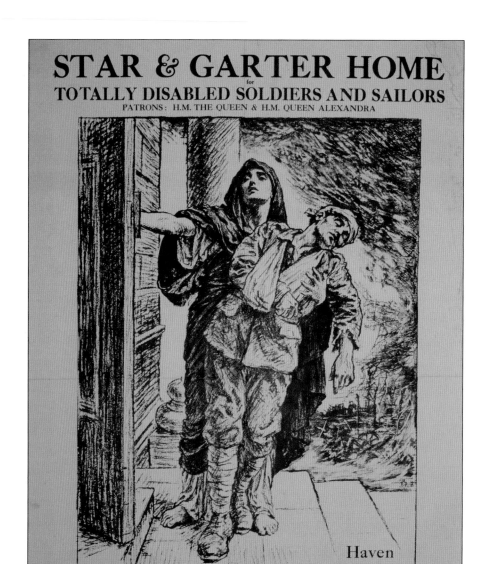

Many historians regard the true cost of the war not simply in terms of the dead, but also the wounded – the physically maimed and mentally damaged who required constant care for the rest of their lives. Queen Mary was so concerned about available care for the badly wounded that in 1915 the old Star & Garter Hotel in Richmond, Surrey, was purchased and converted into a Home with disabled access; the first sixty-five men were admitted in 1916. Their average age was 22. Britain alone had over 1.6 million men wounded, of whom some half a million were never able to lead normal or productive lives again. A purpose-built home replaced the old hotel in 1924.

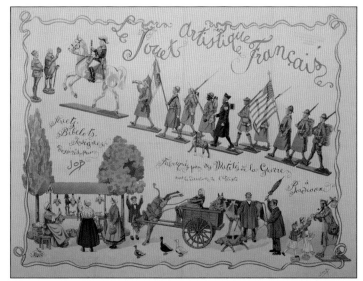

'The French artistic toy drawn by the artist Job. Built by wounded soldiers in Bordeaux.' Mrs Prom and other influential women started 'the French artistic toy'. The artist Job drew the models, which could be copied in beech wood by war invalids in re-education facilities. The toys, with mostly civilian and animal themes, were first displayed in 1916 and would continue to be sold until 1935. This kind of production was also done by the occupied population in Belgium and, in a more warlike fashion, by British wounded and Belgian refugees.

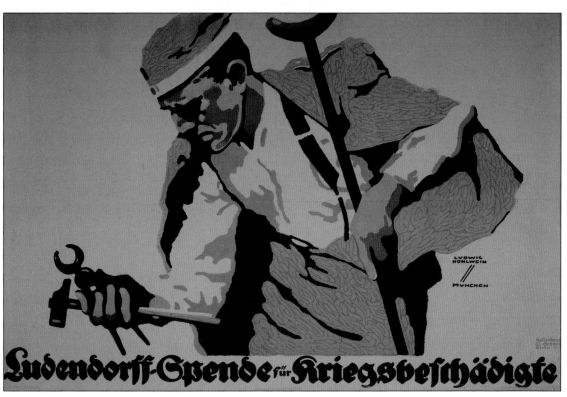

'The Ludendorff donation for war wounded.' Ludwig Hohlwein transformed the art of posters. As early as 1906, in his first posters, he had parted with the typical crayon drawings to adopt big juxtaposed colour patches that created shades and stark contrasts. The result was at once one of great simplicity and powerful realism. His prolific output helped make him an essential figure in German art and contributed to the image of the determined – even when wounded – soldier. In the Second World War Hohlwein was an active Nazi, and his pictures of strong, iron-clad soldiers continued to serve German propaganda.

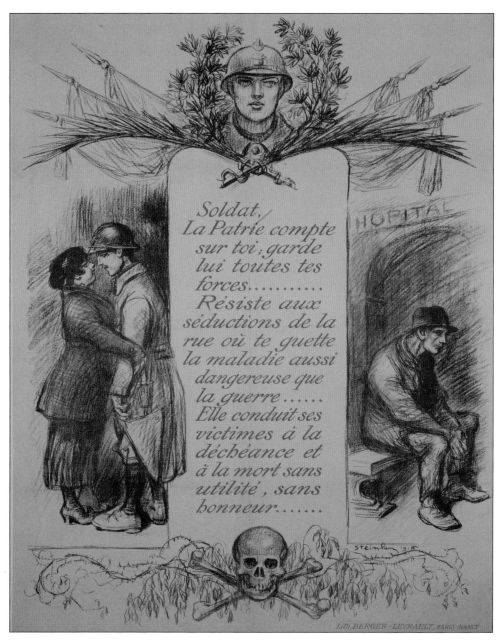

Soldat,
La Patrie compte
sur toi, garde
lui toutes tes
forces..........
Résiste aux
séductions de la
rue où te guette
la maladie aussi
dangereuse que
la guerre......
Elle conduit ses
victimes à la
déchéance et
à la mort sans
utilité, sans
honneur.......

'Soldier. The country is counting on you. Keep all your energy for her. Resist temptations on the street where sickness awaits you, as dangerous as war … It leads its victims to decline and death without any use and any honour.' Broaching such a subject was delicate. Soldiers were supposed to be paragons of virtue, embodying the noblest values of the country. Nevertheless, this vision did not prevent, for example, 50,000 Americans from being on sick leave due to sexually transmitted diseases at any given time during the war. This reality increased manpower problems. To counter this, the message here is based on moral considerations and strongly condemns any weakness as a lack of commitment to the war effort.

'The last blow is the 8th war loan.' German art was heavily influenced by ancient Greek and Roman culture, as well as by medieval imagery. Since the end of the nineteenth century nudity had again become a symbol of superhuman qualities. The strength and beauty of the body are central to this composition as the timeless soldier is recognisable only by his steel helmet. This classical representation places the warrior in the lineage of gods and heroes. Such idealised posters helped to minimise the massive death toll of the Great War and the growing possibility of defeat for Germany.

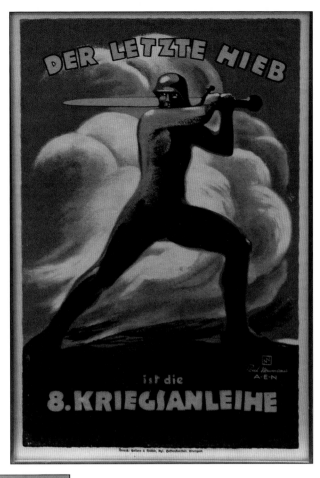

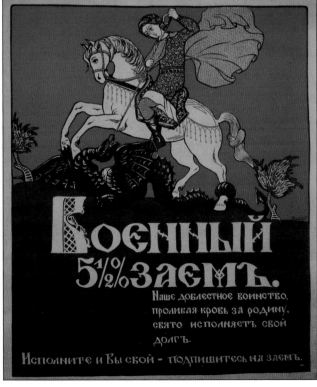

'War loan 5.5%. By giving their blood for the country, our courageous soldiers are doing their saintly duty. Do yours too, subscribe to the loan.' By the turn of the century the medieval knight had become a unifying figure for the German nation and its war-preparedness, embodying the military and aristocratic traditions that had been upset by the economic transformations of the industrial age. Imagery depicting St George, Siegfried and other knights battling dragons was therefore widely used in most warring nations. The iconic past became a way of explaining the modern, technological war in simple antagonistic terms. The hero fought Evil, often in a dehumanised form.

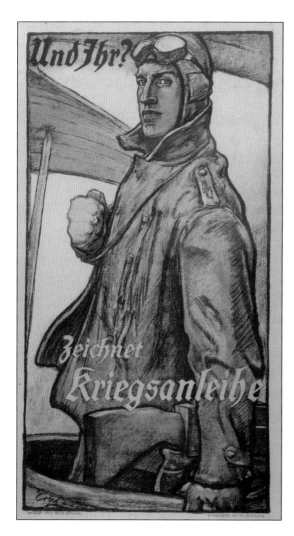

'And you? Subscribe to war loans.' In what was essentially a war of anonymous masses pitched against one another, aviators quickly became the modern equivalent of the medieval knight jousting alone. The fighting in the skies was described as duels, where daring and skill carried the day. The best pilots qualified after five victories for the prestigious title of 'ace'. Among the most famous were the German Manfred von Richthofen, better known as the Red Baron, who scored eighty victories, the British Edward Mannock (seventy-three) and the Frenchman René Fonck (seventy-five). The press eagerly recounted their exploits, turning them into heroes who became role-models.

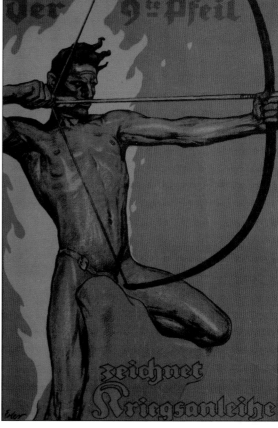

'The 9th arrow. Subscribe to the war loan.' During the war the bowman/archer and his weapon were a recurring theme in war posters because it gave a specific and clear goal and enabled the artist to show an enemy that was already hard hit. Even before Goethe's and Hegel's writings, heroic nudity was a classical element of the idealised fighter. Its epic dimension negated total industrial war and created an aura of invincibility that was disconnected from the realities of the field. Particularly in Germany, this representation foreshadowed the imagery of later war monuments.

This American poster has a somewhat different theme, relating directly to perhaps the most famous of French historical figures, Joan of Arc, and aimed directly at women, who are urged to buy savings stamps, a low-cost form of bonds. The image is a very finely executed one by William Haskell Coffin (1878–1941), who was well known for his very popular magazine cover paintings of beautiful women. His wife, whom he worshipped, is believed to have posed for the Joan of Arc portrait. Sadly, for it was a great loss to the art world, he committed suicide after his divorce in 1940.

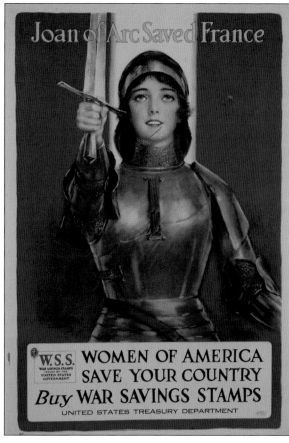

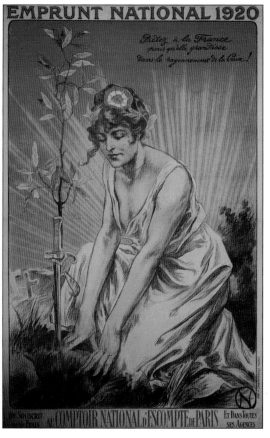

'National loan 1920. Loan your money to France so that it may grow in the shining light of peace. One can subscribe without fee at the national discount counter and in all its agencies.' The allegorical Marianne figure, crowned with the laurel wreath of victory, has here only a cockade to identify her. The Model 1886 bayonet, symbol of the fighting spirit of 1914, has been turned into a peaceful garden stake. The importance of the land in a predominantly agricultural society is therefore very present but the wooden crosses in the background serve as a reminder of the sacrifice of the men.

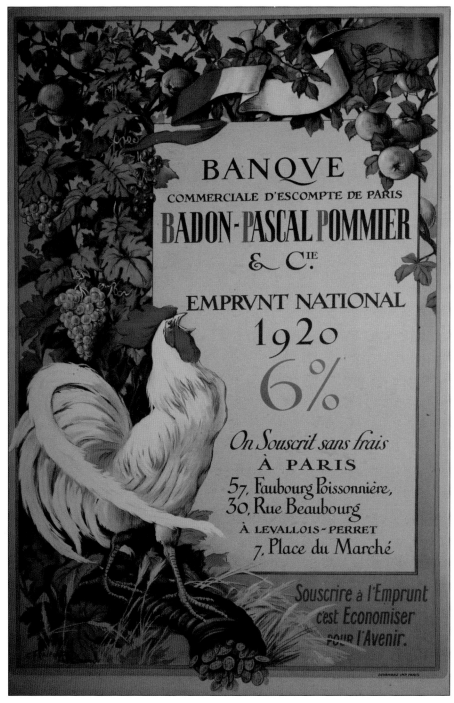

'National Commercial Bank of Paris. Badon-Pascal Pommier and Company. National loan 1920. 6%. To subscribe is to save for the future.' The Gallic rooster had been the unofficial symbol of France since the Middle Ages. During the Great War the cockerel was both a catholic symbol of hope for the return of Christ, and a Republican symbol of the Gauls considered to be the first Frenchmen. The singing cockerel was widely used in 1914 and 1915 to signify that victory was imminent and again, for obvious reasons, from 1918 onwards.

'Teufel Hunden.' A cartoon poster representing the German Army as a dachshund but, unusually, the US Marines as a bulldog (an image more normally associated with Britain). Marine legend has it that after the intense fighting for Belleau Woods in 1918 the marines were known by German soldiers as 'Devil dogs', but as with many wartime myths there is no factual evidence to back this up. In fact, the term was used by at least two newspapers prior to the battle and no evidence from German sources has ever been found to substantiate this claim.

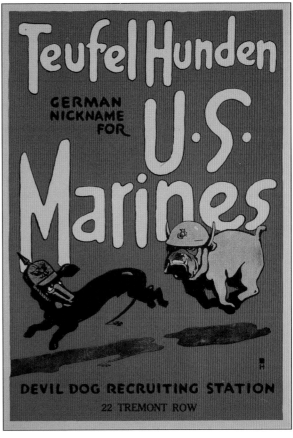

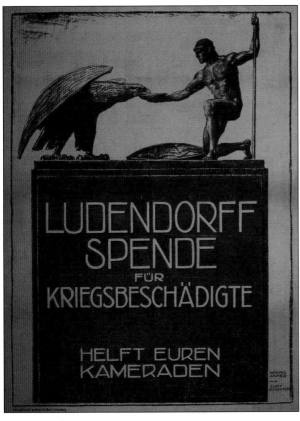

'Ludendorff fund for war victims. Help your comrades!' The eagle had been the heraldic animal of German kings since the fourteenth century and symbolised the German Empire. It is here being fed by a Greek soldier. The classic aesthetic of masculine beauty transcends the reality of a modern war, making a highly positive self-image for the world war soldier: they are seen not only as fighting on the borders but as actively helping the very heart of the nation. The use of images from the much valued mythologised past reveals the trend in mainstream fine arts back to traditional standards that were readily understandable, yet gave a greater meaning to the participants of the war.

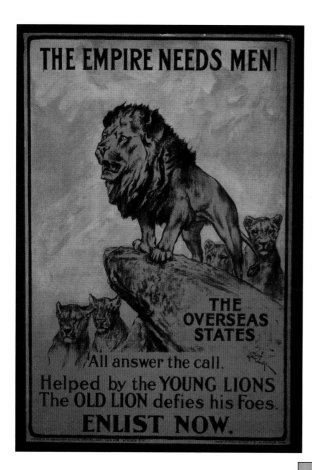

Unlike the German eagle or French cockerel, animals do not often feature in British posters, but this one by Arthur Wardle (1860–1949) is a fine example of the use of a professional artist who specialised in animal painting. It shows a pride of lions and is specifically aimed at the recruitment of dominion soldiers from the 'Overseas States'. Wardle was to become the most significant painter of dogs in the twentieth century.

This rather pleasing poster of a small dog begging for donations for the International Red Cross was painted by American artist Richard Fayerweather Babcock (1887–1954) and was one of several he undertook for it. The International Red Cross Organisation was founded in Geneva by Jean-Henri Dunant in 1863 to provide humanitarian aid without discrimination. Hundreds of men joined to act as ambulance drivers and medical staff, and they suffered a higher proportion of killed and wounded than any other volunteer unit during the war. Some measure of the level of support the Red Cross provided to the warring factions is that it was awarded the Nobel Peace Prize in 1917, before the war had even ended.

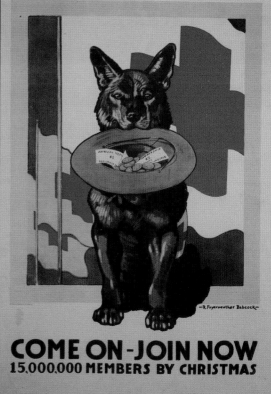

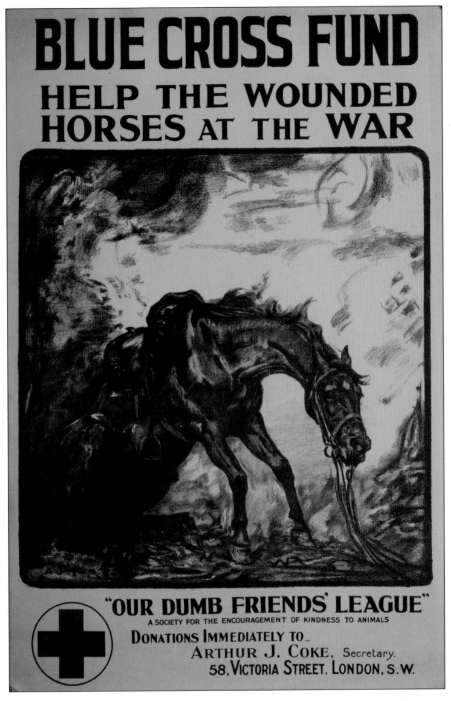

The armies of the Great War were still largely horse-drawn but the plight of the animals went largely unrecorded. Some idea of the scale of the carnage can be gleaned from the fact that over 8 million horses and mules on all sides were killed during the war, and over 2.5 million were wounded and received treatment. Britain employed over a million, but after the war only 60,000 were returned home. The Blue Cross was founded in 1897 'for the encouragement of kindness to animals' and the charity still works tirelessly to alleviate suffering to any animal.

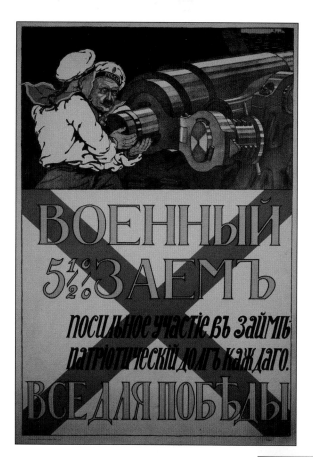

'War loan 5.5%. Forthright participation in the loan is everyone's duty.' Controlling the seas was a major issue for the Russians. Imports soared with the war, forcing Russia to depend on its allies for a great deal of wartime production. Archangel port near the Arctic Circle could only be used during the warmer months, and in the south the Turks held the Dardanelles Straits giving access to the Mediterranean. The Pacific ports were soon saturated. Depicting a determined naval gun crew was therefore not only a matter of pride but also a way of showing a matter of vital importance: this gave the call for war loan subscriptions a real sense of urgency.

'Give for the submarine fund.' Artists did not always draw specifically for posters. One of the Kaiser's favourite naval artists, Willy Stöwer, painted submariners as heroic adventurers in a wild environment. He turned one of his works into this 1917 poster by simply adding the text. He also sold his works printed in postcard format and gave the profit to help submariners. Adapting images to a variety of sizes and media was commonplace during the war. Famous posters, postcards or drawings could then even be copied by soldiers for their trench art.

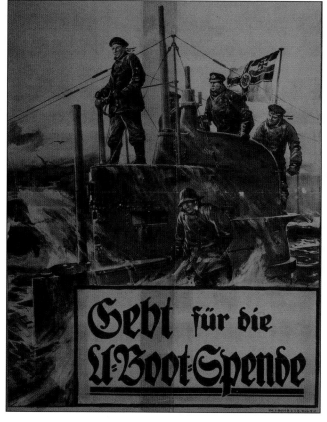

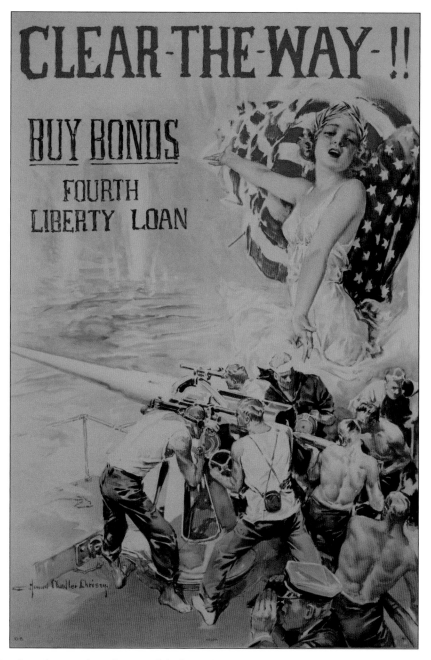

Continuing the marine theme, this fine piece of work by Howard Chandler Christie (1873–1952) depicts a muscled, toiling gun-crew in an almost Greek-heroic mould. Christie was no stranger to war art, having been employed as an artist during the Spanish–American War of 1898. As with his contemporary Harrison Fisher, it was Christie's depiction of women, particularly the 'Christie Girl', that won him lifelong fame, and this is evidenced by the thinly clad girl encouraging the crew. After the war public taste in art changed, and Christie became a portrait painter, producing excellent works of half-a-dozen presidents, and numerous celebrities such as Amelia Earhart, Will Rogers and Benito Mussolini, among others. His massive work 'The Scene of the Signing of the Constitution' hangs today in the Capitol building.

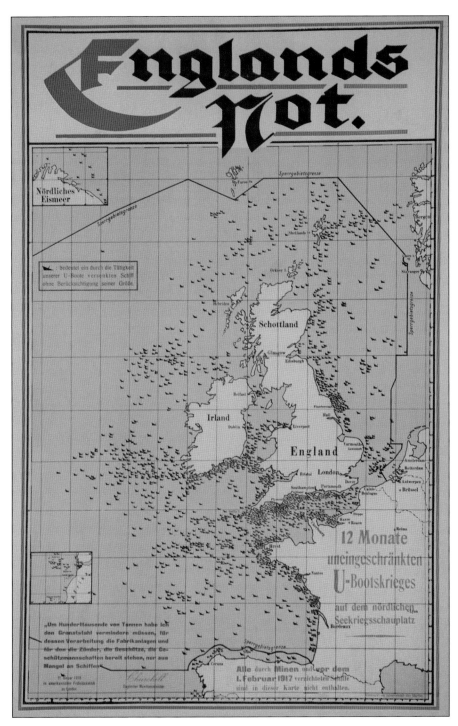

'England's distress. 12 months of unrestricted submarine warfare in the North Sea theatre. Ships sunk by mines or sunk before the 1st of February 1917 are <u>not</u> shown.' The 1916 fighting convinced the Germans that the war couldn't be won on land, and on 30 January 1917 for all-out submarine warfare. Ironically, this poster was produced when it was clear that this strategy had failed. It had not knocked Britain out of the war and had even encouraged the United States to side with the Allies.

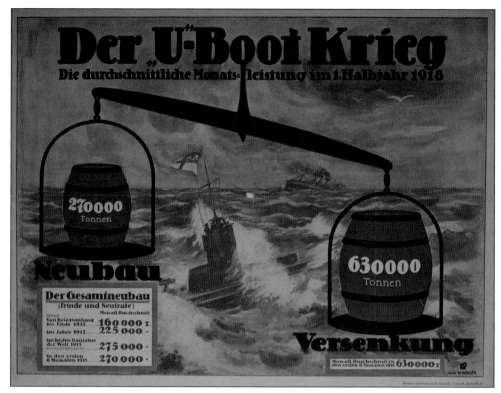

Der „U-Boot Krieg"
Die durchschnittliche Monats-leistung im 1.Halbjahr 1918

270000 Tonnen
Neubau

Der Gesamtneubau
(feinde und Neutrale)

	Monat.Durchschnitt
Von Kriegsanfang bis Ende 1917	160 000 t.
Im Jahre 1917	225 000 "
Im besten Baujahre der Welt 1913	275 000 "
In den ersten 6 Monaten 1918	270 000 "

630000 Tonnen
Versenkung

Monatl. Durchschnitt in den ersten 6 Monaten 1918 630000 t

'The U-boat war. Average monthly achievement in the first half of 1918.' The use in posters of seemingly objective documents to manipulate opinion can be traced back at least to the French Revolution. Even by using a dramatic visual image and unrealistic comparisons, this poster cannot hide the fact that by the summer of 1918 allied production was nearly three times greater than its losses to German depredation –and was rapidly increasing. The massive use of distorted figures would give the word 'propaganda' a negative overtone it didn't have before the war.

Shoot Ships to Germany and help AMERICA WIN—*Schwab*

At this Shipyard are being built ships to carry to our men "Over There"—Food, Clothing, and the Munitions of War.

Without these ships our men will not have an equal chance to fight.

The building of ships is more than a construction job—it is our chance to win the war.

He who gives to his work the best that is in him does his bit as truly as the man who fights.

Delays mean danger.

Are you doing your bit?

Are you giving the best that is in you to help your son, brother, or pal who is "OVER THERE"?

UNITED STATES SHIPPING BOARD EMERGENCY FLEET CORPORATION

Not all the posters provided a clear message. This 1917 example from the United States Shipping Board Emergency Fleet Corporation has a rather obscure meaning, asking if the reader is 'giving their best', although in exactly what capacity is unclear. It is not a recruitment poster, but appears to be aimed more at workers, as the text is taken from a speech by Charles M. Schwab (1862–1939), owner of the vast Bethlehem Steel Corporation, who was accused of profiteering after the war. The fine artwork is by Arthur Triedler and depicts a dazzle-camouflaged merchant vessel.

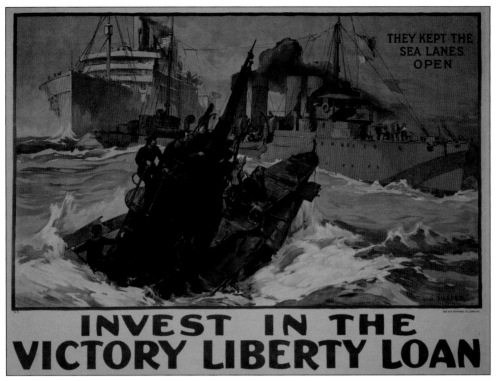

This marine poster is another with a confusing message, although it is more visual. At first glance the painting by Leon Schafer (1866–1940) appears to be showing an attack by a submarine on a merchant ship, but a closer look shows the submarine is sinking, implying that the destroyer has managed to disable it – in reality an unlikely scenario. There was no doubt that the food and munitions supplied to Britain by US merchant shipping managed to keep her war effort going, although at a cost. Britain imported £1,559,900,000 worth of food and war materiel between 1914 and 1918.

'Big military concert!' Concerts remained an important cultural activity throughout the war on all sides. For the Germans, it was also a way of showing their presence in occupied territory, just as the proud display of a (giant) trench mortar of the 4th Battalion on this poster is a way of showing the country's military strength and therefore future victory. But music was first and foremost a way of relaxing. For professional musicians such as those mentioned on this poster, concerts proved indispensable, if only to keep their touch. Those who were not officially army musicians also found ample opportunity to practise their skills, including for the highest ranking officers.

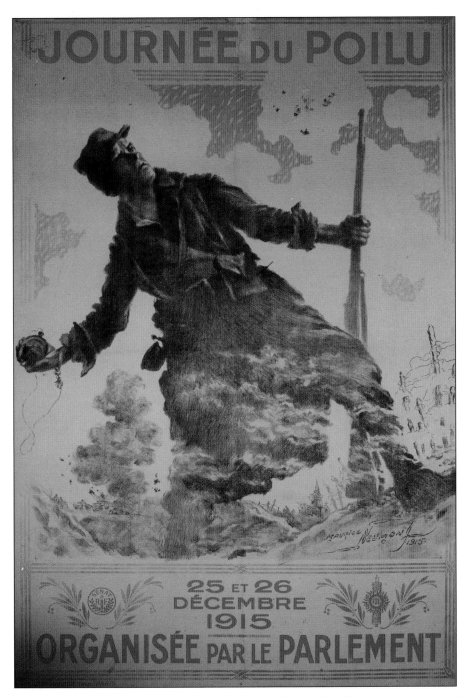

'Poilu Day. 25 and 26 December 1915. Organised by the Parliament.' Artists tried to follow the technological evolutions of the war. Facing the unexpected challenge represented by trenches, the warring nations had to resort to out-dated equipment. Siege warfare techniques and grenades were experimented with anew. This French Poilu is using a rudimentary hand grenade with a rather dangerous fuse. In 1915 the shortage of grenades was so acute that soldiers would improvise by filling old jam tins with powder and nails. In every country a whole new industry had to be created to answer the war's needs.

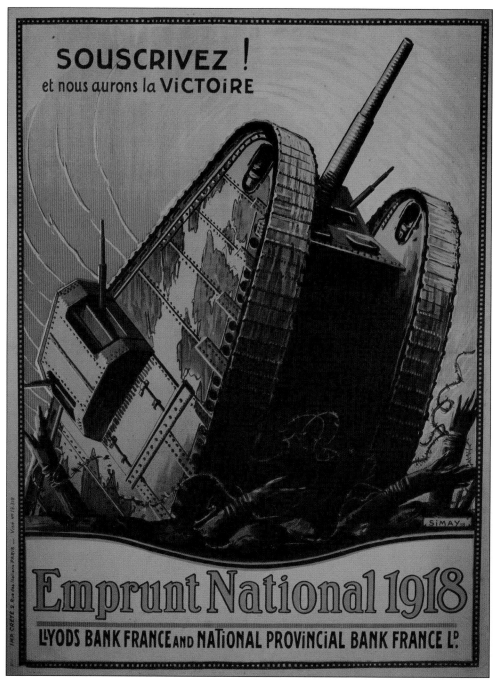

'Subscribe! and we shall have victory. National Loan 1918.' Propaganda of all kinds equated technological superiority with certain victory. By 1918 images of tanks were well known to the public, especially in photographs showing them overcoming trenches and shell holes. Simay has here also very clearly rendered the tank's function of opening a way for the infantry by crushing and snapping the barbed wire. His decision to add an unrealistically long cannon further accentuates the diagonal upwards movement. He thus creates the strong impression of a force capable of crushing any obstacle in its way.

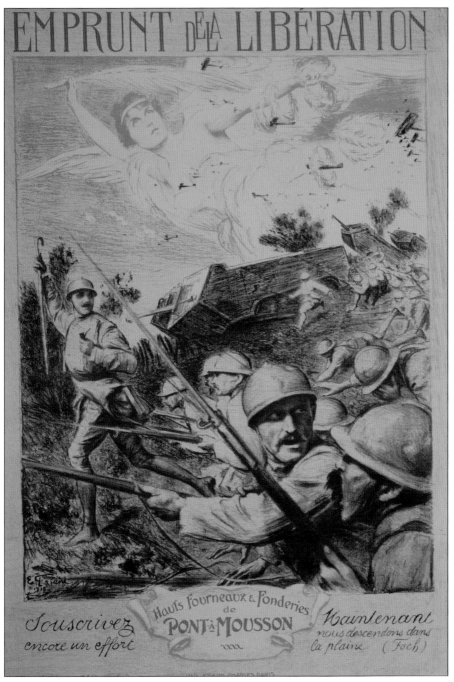

'Liberation Loan. Subscribe now. "One more effort – we are descending into the plain" (Foch). Pont à Mousson Steelworks.' As victory seemed finally possible, the Allies started using enthusiastic images of war again. As the town of Pont à Mousson had been almost part of the front lines for four years, pushing back the enemy was no abstract goal. This attack combines the determined French Poilu with a crushing material superiority: St Chamond tanks and a multitude of aeroplanes open the way. Here too, the allegory of Victory leads the attack, with a gentlemanly officer. The metal produced by the steelworks is shown to have a direct use in saving the city.

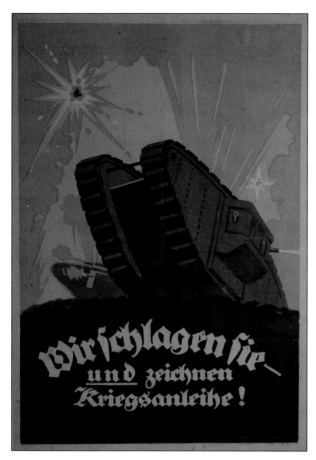

'We're defeating them – and you subscribe to war loans!' Images became increasingly important as the war progressed because their message suffered little from contradiction or confusion. Ironically, showing the crushing power of (captured British) tanks focused the attention precisely on one of Germany's weaknesses. During the Great War the German High Command dismissed tanks as an expensive, inefficient toy. By 1918, despite the reorganisation of all German industry towards the war effort, Germany was no longer capable of matching the Allies' output: Ludendorff would later argue in his memoirs that the metal needed for tanks would have had to be diverted from submarine production. This poster is a classic example of propaganda turning a problem into an asset.

'"The Hour" has discovered the machine to end the war. A novel in instalments by Gignoux and Dorgelès starting on March 27th (1917).' Despite the widespread use of traditional figures, certain posters admired modernity and technical progress. This advertisement captures the violence of the war despite the novel's satirical tone denouncing war profiteers and naïve patriotism. The poster combines the new weapons which so impressed the men of the times. The tank shoots gas to exterminate mercilessly the fleeing Germans. This image of total victory contrasts with H.G. Wells's pessimistic views of alien invasion in the *War of the Worlds* (1898). The modernist approach opened the way to a whole generation of new posters in the 1920s.

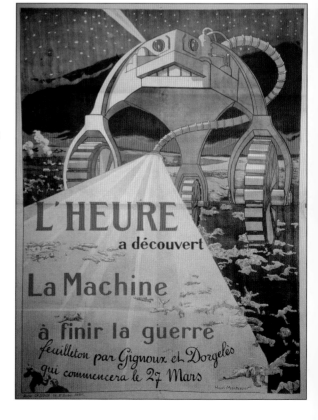

Chapter 4

The Enemy

T he absolute conviction during the Great War of each nation's superiority meant that allies were applauded for their intelligence and loyalty, but it also meant that enemies had to be lowered in the public's estimation still further. Showing your enemy was the second most fundamental aspect of efficient propaganda based on attraction and repulsion.

Images of the enemy did not appear out of nowhere but were based on prewar differences in lifestyle, custom and attitude. These could be simply picked up in newspaper caricatures but may also have been justified by the church hierarchy or by prestigious intellectuals. During the war French scientists even claimed to have identified a smell that was particular to the Germans. All these elements combined to create unquestioned distinctions between 'Us' and 'Them'. Distinctions could then be radicalised into a clear-cut separation of Good and Evil, Pure and Unclean, Holy and Beastly.

During the war the posters' based their depiction of the hated enemy on, for example, historical imagery or on the rejection of his primitive or 'twisted' decadent social values. In this context figures of the enemy could range from simple depictions to fearful caricatures and even to completely dehumanised foes. In fact, the Great War can be characterised by its immediate radical mobilisation: the French produced innumerable representations of the hateful Germans within days of the outbreak of the war. They were systematically portrayed as barbarian Huns, and were often reduced to a mere spiked helmet. The Germans were less visually aggressive during the war, perhaps due to the fact that they had won their previous war against France and were, throughout almost the entire Great War, fighting on foreign soil. Nevertheless, they despised the British for what they considered an unfair involvement in the war based only on materialistic 'business as usual' considerations. After their defeat, and with the rise of communism, German posters would become far more overtly radical.

This begs the question of what kind of violence could be shown. Ridiculed, deformed, inhuman enemies were countless. Flows of blood, tainted bayonets and even mutilated bodies with their tormentors might also be shown. The depiction of atrocities of all kinds rang out as a warning against any demobilisation, and justified in Christian societies the act of killing. If the enemy was not human, it was morally more justifiable to eliminate him. It also prevented any attempt to find a negotiated peace, as it became unacceptable to negotiate with such monsters. Hateful images therefore had within them their own radicalisation.

However, violence was accepted only to a certain degree. For example, when Frank Brangwyn drew an American bayoneting a falling German soldier, the image shocked the public because it was disturbingly realistic. It seems that, in posters at least, showing the physical act of killing was often the limit: bullets are not shown tearing through flesh and the raping German was only hinted at with the image of a soldier dragging off a woman or a young girl.

Nevertheless, the most radical emotions could be stirred up against a clear threat, for the wildest, crudest fantasies could be drawn, and this process could be very useful in mobilising the productive effort needed to win the war. Posters about the enemy explain remarkably clearly how societies at war see themselves and their place in the world around them. Nowhere is national ideology more distinctly defined than in the representation of the enemy, the difference between the imaginary and reality so clear.

'The enemy is listening in! Be careful!'
The telephone was widely adopted in
1915, before being replaced in 1916–17
by radio and other communications
methods. In order to avoid
interceptions, telephones were only used
a mile away from enemy lines. Such
posters existed on both sides of the
Western Front. When the code war was
finally mastered at a late stage in the war,
the use of bluff became more
widespread. For example, the Allies
purposely reduced their radio signals
before the 1918 Battle of Amiens.

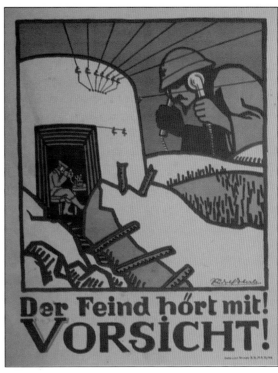

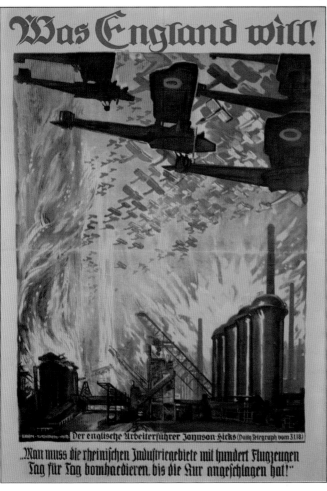

'What England wants! The British
trade unionist Johnston Hicks (Daily
Telegraph dated 3 January 1918):
"With hundreds of planes we must
bomb, day after day, the Rhineland's
industrial area until the cure has
taken effect".' By 1918 the new levels
of violence induced by a total war
were acknowledged by all. Aerial raids
against cities and factories were
already being carried out and made
this poster quite credible to German
audiences. Through stirring up fear
and hatred of the enemy, it aimed at
remobilising the German population
which could otherwise have been
tempted by a peace-making policy
such as returning to the prewar status
quo with no annexing of new
territories.

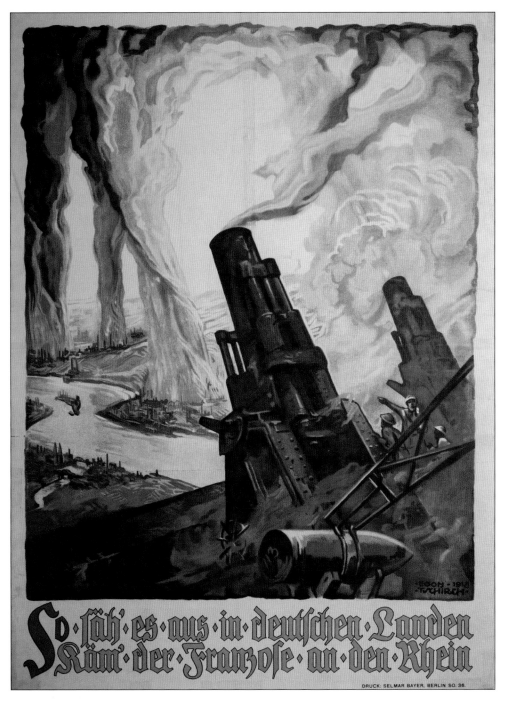

'How it would look in German regions if the French arrived on the Rhine.' No major battle had taken place on German soil since the victory at the Masurian Lakes in the winter of 1914/1915. However, the war had made the Germans all too aware of the destruction wrought by an industrial war, and in 1918 they were still determined not to have to fight on their own territory. This feeling can best be summed up by the fact that the old patriotic song 'The Watch on the Rhine' had been turned into 'The Watch on the Somme' by 1916.

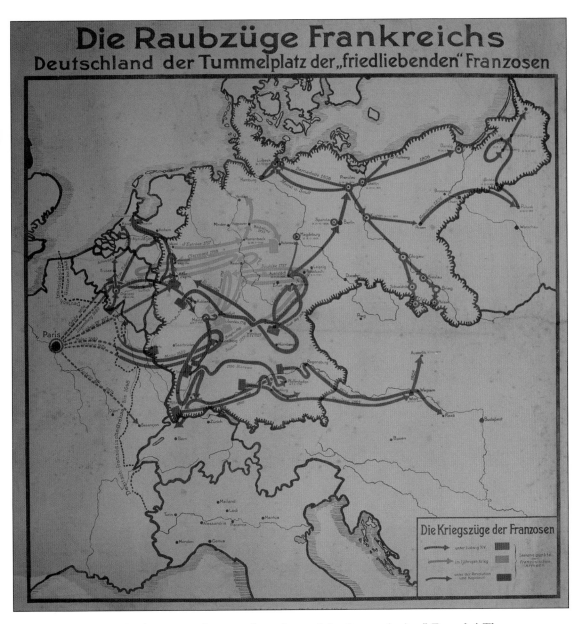

‘France's raids. Germany, the romping place of the "peace-loving" French.' The map of Germany shows the moves of the French armies during Louis XIV's reign (1638–1715), the Seven Years' War (1756–1763), and the Revolutionary and Napoleonic wars (1792–1815). It appears that the French have constantly pushed further into German territory. By ignoring conflicts such as the Franco-Prussian war of 1870–1871, this map makes it clear that no part of Germany would be safe in the event of an Allied victory.

'The 7th Army "Art at the Front" exhibition.' This original poster-drawing contrasts, in a humorous way, the French elite Chasseur with the supposedly cowardly German soldier. The French had a mental image of an enemy whose fighting power derived solely from brutal discipline. This representation of a degenerate German only too happy to be taken prisoner simultaneously reassured the French and denied their enemies any respect. Fighting was thus made easier because it was justified.

'Bignon Bank Abbeville: "I make war". Subscribe, the cleaning up will go faster.' The humour of the Somme bank's poster derives from the 'hygienism' approach to different nationalities. The strong, healthy French soldier is a model of masculinity, while his German counterparts are no more than helpless parasites. The surrendering figure and his fleeing comrade are both unarmed. The picture suggests a painless task of getting rid of them. However, the text suggests an emergency: Prime Minister Clemenceau's famous words 'Je fais la guerre' show the total mobilisation needed to achieve certain victory.

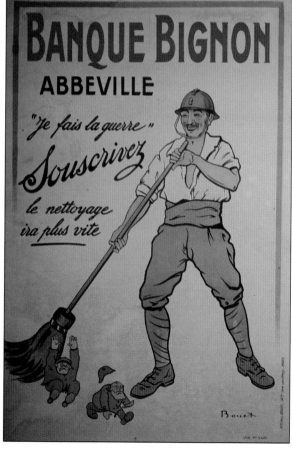

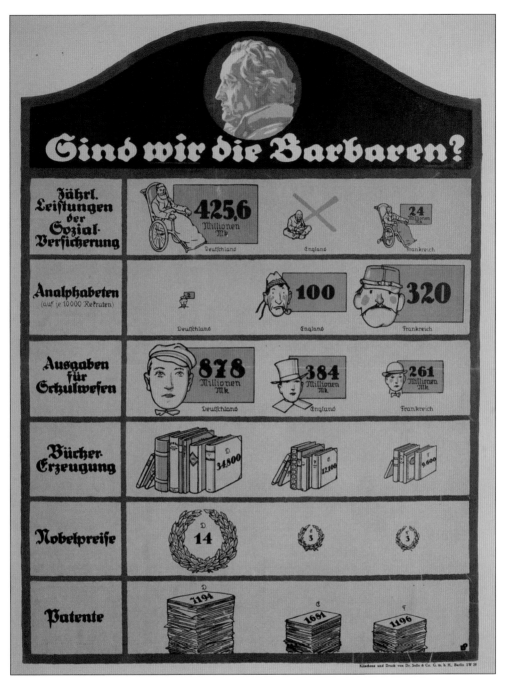

'Are we the barbarians?' German propaganda often used facts as a way of convincing the reader, instead of relying solely on the emotional impact of the image. This approach is based on a traditional view of propaganda: it is considered as an ongoing dialogue between nations, each offering its outlook on events. This poster compares the amounts spent on education and retirement pensions, as well as the number of Nobel Prizes and illiterates, in order to demonstrate German cultural superiority. Nevertheless, the war proved to be a turning-point in German political posters as even-sided arguments gave way, particularly in the 1920s and 1930s, to ever-more shrill and biased messages.

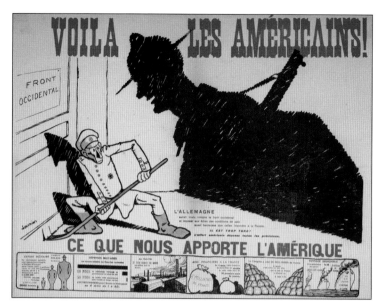

'Here come the Americans!' A humorous cartoon depicting a looming Doughboy and a cowering Crown Prince. Kronprinz Wilhelm was always portrayed in French caricatures as the 'Prince of Thieves', and always had a stolen object with him. Here 'Little Willie' is about to be punished. The artist's optimism is justified by the boxes at the bottom, illustrating the huge amounts of munitions, food and men that the US was bringing into the war. The lower slogan points out 'This is what America is bringing us.' As a curious aside, the American soldier has a British Lee-Enfield rifle slung on his shoulder!

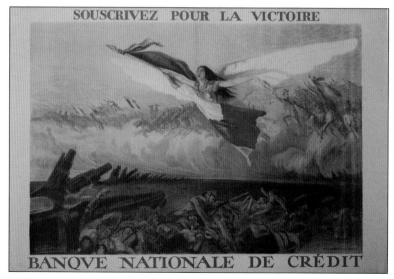

'Subscribe for victory. National Bank of Credit.' Although the artist, Michel Richard-Putz, insists on the Allies' victorious charge, he totally avoids actual combat and the act of killing. It is as if the enemy has already been destroyed. This illustration is typical of the way the war was depicted. It was easier to show the aftermath of a battle. In this case, the heaps of dead bodies and the piles of shattered cannon seem to have been caught by devastating fire while on the march, but blood is hardly visible.

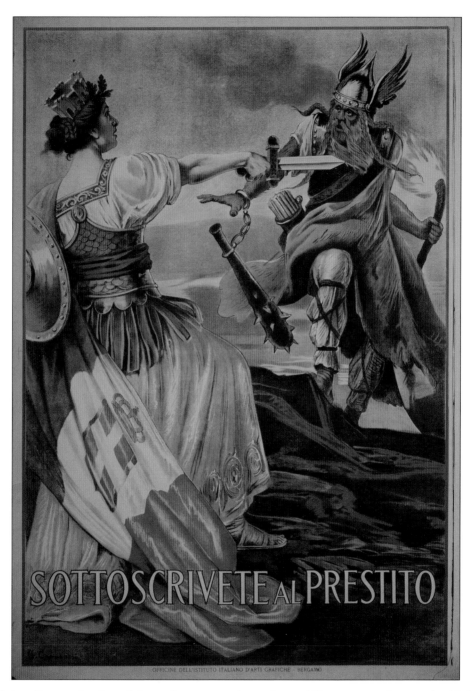

OFFICINE DELL'ISTITUTO ITALIANO D'ARTI GRAFICHE · BERGAMO

'Subscribe to the loan.' In order to convince the public, many artists used widely accepted aesthetic representations. The female 'towered Italy' allegory dates back to the second century, when it already symbolised the sovereignty of Roman citizens. The enemy, stylised as a barbaric Gaul, serves as a reminder of the fall of Rome in 390 BC. By referring back to the traditional, classical opposition of Beauty and Ugliness, of Good and Evil, the artist Capranesi provides a clear link between the war loan and the halting of an impending invasion. By doing so, he also placed the Italians on the moral high ground: the allegorical figure of Italy is defending her honour and her land.

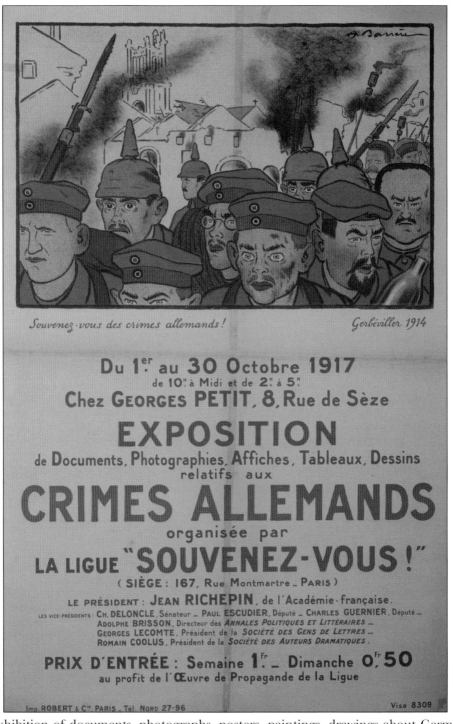

Souvenez-vous des crimes allemands !

Gerbéviller 1914

Du 1^{er} au **30 Octobre 1917**
de 10^h à Midi et de 2^h à 5^h
Chez GEORGES PETIT, 8, Rue de Sèze

EXPOSITION
de Documents, Photographies, Affiches, Tableaux, Dessins
relatifs aux
CRIMES ALLEMANDS
organisée par
LA LIGUE "SOUVENEZ-VOUS!"
(SIÈGE : 167, Rue Montmartre - PARIS)

LE PRÉSIDENT : JEAN RICHEPIN, de l'Académie-française.
LES VICE-PRÉSIDENTS : CH. DELONCLE, Sénateur - PAUL ESCUDIER, Député - CHARLES GUERNIER, Député -
ADOLPHE BRISSON, Directeur des ANNALES POLITIQUES ET LITTÉRAIRES -
GEORGES LECOMTE, Président de la SOCIÉTÉ DES GENS DE LETTRES -
ROMAIN COOLUS, Président de la SOCIÉTÉ DES AUTEURS DRAMATIQUES.

PRIX D'ENTRÉE : Semaine 1^{Fr} - Dimanche 0^{Fr} 50
au profit de l'Œuvre de Propagande de la Ligue

Imp. ROBERT & C^{ie} PARIS - Tél. NORD 27-96

Visa 8309

'Exhibition of documents, photographs, posters, paintings, drawings about German crimes organised by the "Remember" league.' Traumatised by the experience of the 1870–1871 war, during which French civilians shot them in the back, the Germans were determined to crush all resistance in 1914. In the first months of the war over 5,500 civilians were shot and countless buildings destroyed. These atrocities were denounced, sometimes with much exaggeration, by Allied propaganda.

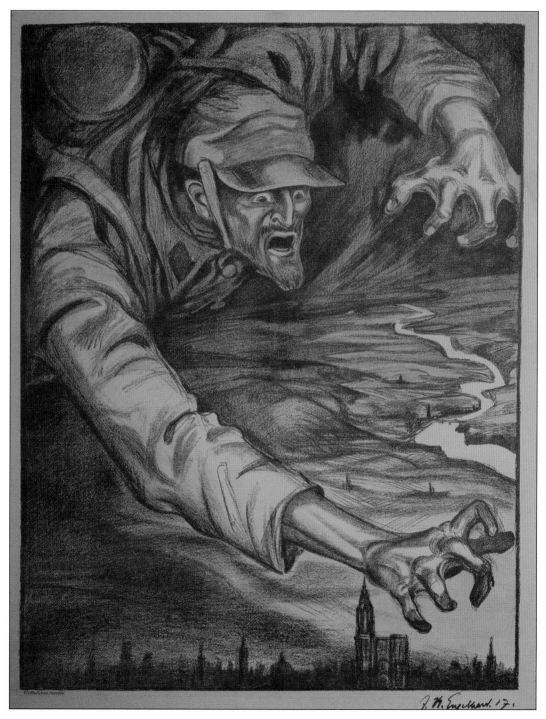

Though French propaganda was often more violent than its German counterpart (in part due to the fact that Germany was fighting on foreign soil), a substantial part of German propaganda did not hesitate to play on stereotypes and fears. The aggressive, grasping Frenchman looming over an idyllic Rhineland was sometimes accompanied by the text 'No. Never!' The postwar Allied occupation would reinforce the image of the horrible sub-human French soldier.

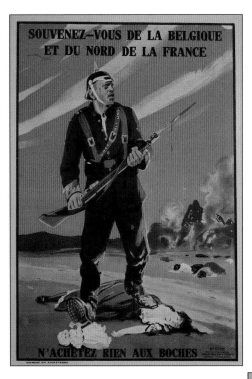

'Remember Belgium and northern France. Buy nothing from the Boches. Printed in England.' Denouncing German atrocities was an easy way to justify the war and keep soldiers and civilians mobilised. The horror of having one's home and family attacked was a constant theme throughout the war. These horrifying images circulated around all the warring countries, and often the same theme might appear simultaneously in different places. There were also exchanges between artists who copied or imitated powerful new representations. It is interesting that this form of imagery was widespread even before war broke out. This French poster explicitly comes from England.

'Once a German – Always a German!' The economic war had preceded armed hostilities. Before 1914 commercial success was for many German industrialists also a way of proving their nation's superiority. Their efforts were successful and entire sectors, notably children's toys and chemical production, were dominated by Germany. During the war French and British posters played on both attraction and repulsion to condemn German products by ceaselessly reminding the viewer of German atrocities, many of them being pure fiction. By influencing postwar business attitudes, these posters encouraged a total mobilisation that went beyond military events, and also revealed the concerns of the day.

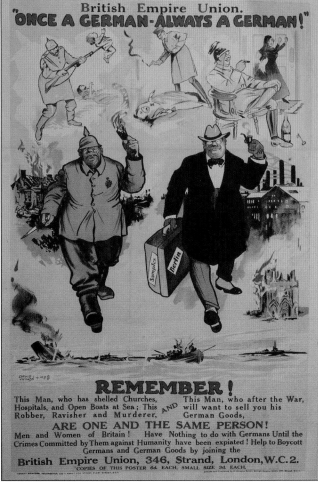

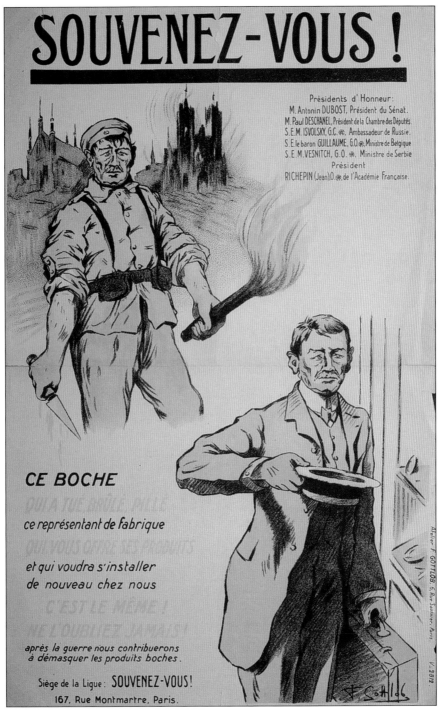

'Remember!' In the prewar years a product deemed to be German could ruin its parent company. For example, the Swiss-based Maggi Company came under constant attack from French milk retailers and the extreme-right Action Française. With the outbreak of the war the simmering hatred in major capitals boiled over: the fear of spies caused rioting, and foreign-named stores were sacked in various cities, including Paris and London.

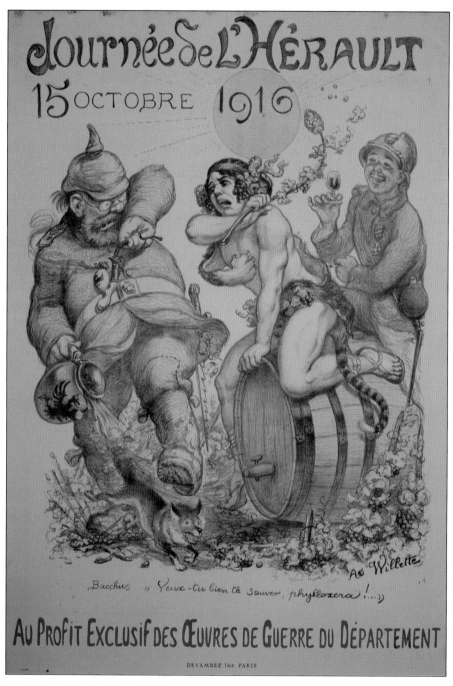

'Herault Day, 15 October 1916. Bacchus: – "Go away, phylloxera!"' In France some thirty-five National Days and countless Local Days were organised to raise funds for all kinds of cause. Volunteers sold paper, metal or even preciously crafted insignia or lapel flags, and over 1,100 different types are known. Just for the 75mm Cannon Day, 22 million insignias were made – more than one for every two French inhabitants! In this case the artist, Willette, has adapted a local concern: in one of the greatest wine-producing regions, he compares the beer-drinking German to the insect that devastated French vines during the nineteenth century.

While the likelihood of German troops ever setting foot on American soil was virtually nil, the image conjured up in this painting is a clever one. The blood-soaked boots with their spurs bear more than a passing resemblance to cowboy boots, rather than jackboots, but the message is clear and graphic, if not entirely honest – buying war bonds would prevent the horror of invasion. It is typical of the posters depicting the enemy as inhuman, and played upon people's most basic fears.

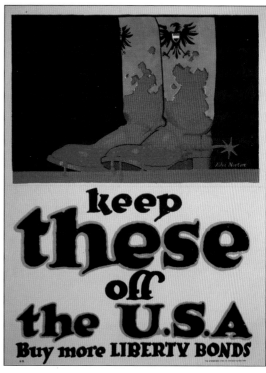

Unlike many of the allegorical images created in Britain and France, the majority of posters produced for the American public were of historical and rather heroic themes, relying on national pride and the ideals of justice and liberty. However, a few posters such as this one used images that were frankly quite frightening. This green-eyed, blood-soaked monster of a German soldier peers out from smoking ruins at the viewer. This was a late war poster, dating from 1918, and it uses the common epithet of 'Hun' for the German soldier. It was the creation of F. Strothmann (1872–1958), himself of German origin, who went on to become a well-known comic illustrator.

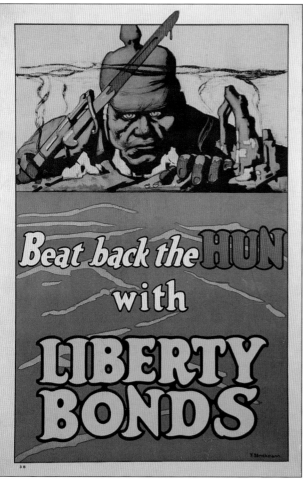

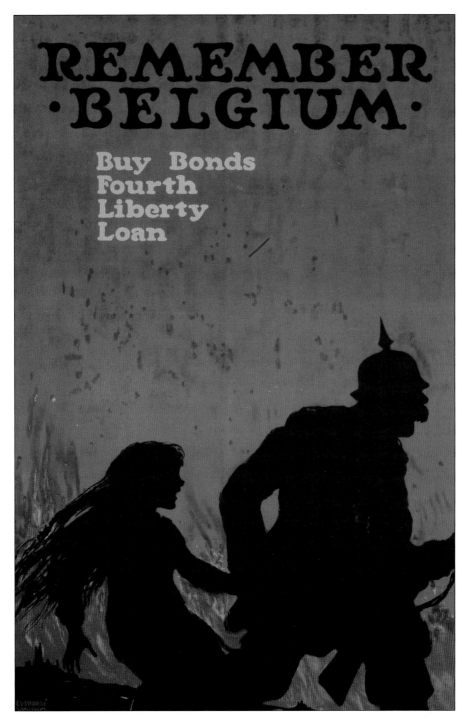

The last of the Liberty Loan posters, produced at the end of the war, this image by Ellsworth Young (1866–1952) is typical of a series showing the brutality of the German invaders. The picture is one of the more subtle and disturbing ones of the whole war, with its implied kidnap of a young girl by a typical picklehaube-wearing German soldier. Young was a very well respected landscape painter and book illustrator, and this cartoon-like image is an unusual but powerful piece of work.

Chapter 5

The Family and the Home Front

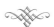

In prewar Europe and the United States there was little interaction between the military and civilian populations in peacetime. Joining the army was often regarded as a last resort for men who were poorly educated or otherwise possessed few skills. Armies existed to fight for their flag and country but what they actually did was rarely reported and such fighting as took place was often in far-flung regions, where news of events filtered back slowly and had little if any impact on the civil population at home.

The First World War was to change this for ever, as it gradually became a conflict that encompassed entire populations and was widely reported. It was, in effect, total war: a concept that hitherto had never existed, where all civilians, from the wealthiest to the poorest, were affected in some way. It was not simply the sheer scale of the war and the numbers of men involved, but the requirement for entire societies to be mobilised to assist in the war effort, be it producing food or munitions, or helping with the wounded. Civilians became legitimate targets for the first time. Paris was bombed in August 1914 and suffered from long-range shelling in the spring of 1918, while German ships shelled the British east coast in December 1914. In 1915 the first Zeppelin raids were launched on London. No longer were the non-combatants at home remote from the effects of war. Curiously, this new danger fuelled greater determination on the part of civilians to help defend their homes. Lurid poster campaigns began in Britain and France, followed in both Germany and the United States, depicting the potential horrors of enemy invasion and asking, in many different ways, what the civilian population could do to prevent this happening. Workers were assured that their jobs, be they dock workers, miners or farmers, were vital to the war

effort. To those not engaged directly in war work, the question was often posed, 'What are you doing – does your job help the war effort?' This was an attempt to persuade more people to work in munitions, or other industries directly related to the war.

In peacetime the female populations would not have been permitted to undertake physical work, the traditional preserve of the men-folk, but this changed very quickly during the war. By 1917 700,000 women were working in Britain in munitions alone, while in France an estimated 500,000 women were involved in war work, with some 80,000 working in jobs directly assisting the armed forces, such as driving, nursing or running front-line canteens. In both countries tens of thousands of women undertook hard labouring work on farms that were denuded of men. In Germany the situation was different as the attitude to traditional female roles was far more rigidly adhered to than elsewhere. Despite calls for women to be actively included in the workforce, the country relied on volunteers and these were not forthcoming in large numbers. The one exception was from the lower class of women whose traditional role had been servants, who embraced the opportunities for new employment. As a direct result of the wide social differences between the European countries, it will be observed that, while there are many examples of British, French and American posters exhorting women to aid the war effort, Germany produced far fewer.

The huge losses in men during the war also had a profound effect on family life, as the traditional role of the man as breadwinner evaporated. Thousands of families became dependent on the wages of the woman, the sole working adult, and this led to a gradual shift in both economic and political power as women demanded the same rights as men. This shift was reinforced by many men returning from the fighting, who were sceptical about political promises and wanted to see the old orders changed. This was particularly evident in Germany, where social privation and the economic collapse of the financial system led to open revolt at the end of the war. The effect that the war had on family and home life is probably impossible to quantify, but there is no doubt that the early attempts to persuade civilians to work for the greater good of the war effort would later have a major effect on how the war was perceived by people who were to be profoundly affected by it. As the Great War evolved from an almost medieval form of warfare into an increasingly mechanised and industrialised conflict, so too was the home front forced to adapt, and by the end of 1918 the concept of civilians as part of the war effort had spelt the beginning of the end of the traditional social roles that had existed through Europe for hundreds of years. The effects of this change are still being felt today.

'The annexing of the left bank of the Rhine. The French war aim! Rhinelander, protect your freedom, subscribe to the 7th war loan.' War aims were not really discussed at the beginning of the conflict. Some French military leaders, such as Foch, did later argue for the annexing of the left bank of the Rhine as a way of securing France's borders. The depiction of Cologne Cathedral in flames echoes the French shock at seeing Reims Cathedral bombed. The fear of defeat was used as a way of remobilising the population.

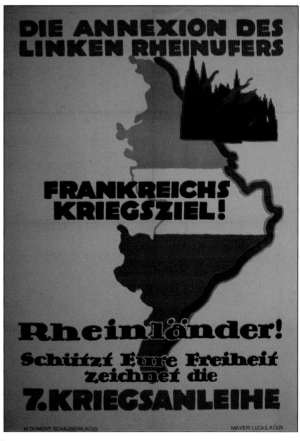

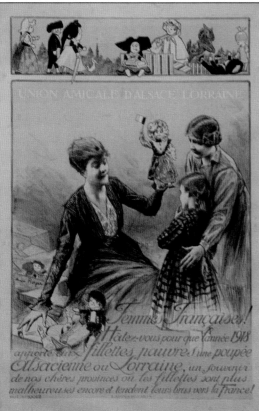

'Alsace-Lorraine Union. Frenchwomen! Hasten so that the year 1918 brings an Alsatian or Lorraine doll to a poor little girl. This will be a souvenir of our dear provinces where girls are even sadder and extend their arms towards France.' The dolls, dressed in traditional clothes, serve as a reminder of French war aims. The French government had forbidden discussion of such aims but conceded in 1917 that the reconquering of Alsace and Lorraine was an accepted fact. In reality, as soldiers' letters made clear, a great majority by then longed for peace and the resumption of a normal, traditional life, but less than 5 per cent of the population accepted peace without total victory. Children were used here as a way of sustaining morale.

'Poilu Day. Finally alone! Organised by the Parliament.' In 1915, with no end to the war in sight, a debate started about soldiers' leave (which was not an automatic privilege in the French Army), and whether a much-needed rest with the family would boost morale. For those in the German-occupied regions, going home was almost impossible. An office was created to welcome these men in Paris, and it raised money through Poilu Days. Some 50,000 copies of this poster, one of six, were printed to advertise the second series of such Days. It simply depicts a reunited couple, and showing this longed-for situation proved very effective: coupled with the Christmas celebrations, these Poilu days were an unparalleled success.

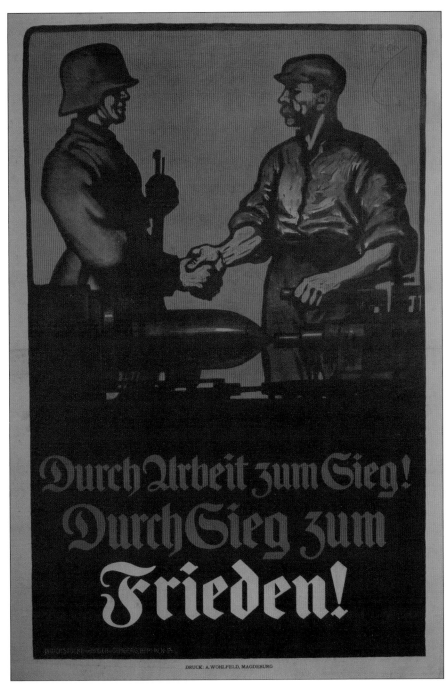

'From work to victory. From victory to peace!' War weariness caused strikes and other delays in production by 1917. Throughout the war, and particularly in the later years, it was necessary to remotivate the population. The intention of this poster is to make overt the link between national production and the war effort, but it goes beyond the classic bond between the elderly munitions worker and the younger soldier, with the text promising not only victory but also, explicitly, peace. It was by then clear that propaganda had to explain that only greater sacrifice could accomplish the longed-for goal of peace.

'French Republic. Ministry of Agriculture. Plant potatoes. For the soldiers. For France.' The occupation of northern France not only isolated the country's strategic towns and industry, but also meant the loss of an enormous amount of agricultural production. Importing food from the colonies or from as far away as Latin America became indispensable. Free distribution of potatoes was widespread in French cities in order to counter food-price inflation and logistical difficulties. The instruction rests here upon the soldier's moral authority to influence the farmer's choices, but many posters would describe food production as the home-front's battle.

The war brought about a fundamental change in the way women were regarded in the workplace in England, as tens of thousands took over roles previously regarded as male-only. With 6 million men in uniform, their contribution was vital in aiding the war effort. The Women's Land Army was formed in 1915 as a civilian organisation that provided women to undertake agricultural work and, despite much opposition from conservative farmers, by 1917 there were over 250,000 women in the scheme. This image was painted by Henry George Gawthorne (1879–1941), who became famous after the war for his LNER railway posters.

Although rationing during the Great War was not as strict in Britain as it would be during the Second World War, by 1916 there were growing food shortages and England was particularly dependent on wheat imports from the United States. In a series of practical posters British households were reminded, using the key as a symbol, that waste was damaging to the war effort. The war years saw the emergence of the food black-marketeer and severe prison terms were introduced for those caught buying or selling illegally.

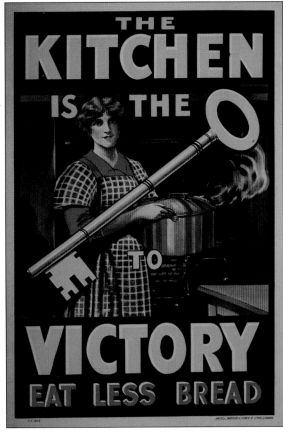

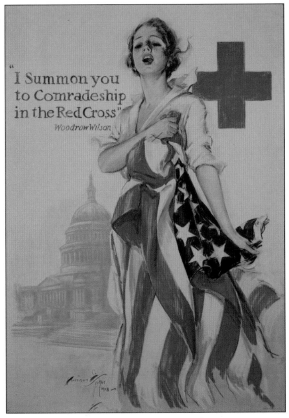

While the quote from President Wilson is clear enough, the actual image here is rather mixed, the woman apparently clutching the American flag with an unusual degree of joy. This is entirely due to the artist, New Yorker Harrison Fisher (1887–1934), who was known as 'the father of a thousand girls'. His magazine and journal covers depicting coy but sexy women graced hundreds of dug-outs and mess walls during the war and were equally popular on both sides of the Atlantic, and 'Fisher girls' were highly sought after – although whether this poster aided the Red Cross effort is a moot point. After his death, one of Fisher's relatives burned over 900 of his original works.

119

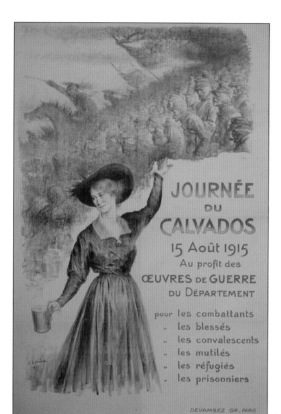

'Calvados Day 15 August 1915. For the country's war charities. For the soldiers, the wounded, the convalescents, the amputees, the refugees, the prisoners.' Charles Léandre concentrated on the female and civilian audience: his drawing of a realistic woman in the midst of collecting donations prepared the population for what they were to expect on the Day. It also subtly calls for volunteers, giving women a role in the event and, more generally, in the war effort: they are to support, almost literally, as on the poster, the soldiers represented as a mixed mass of attacking and wounded men.

The United States had never shied away from the fact that money was the key to its war effort, hence the extremely large number of posters for liberty loans and war bonds, which comprised some 20 per cent of the total output of all posters during 1917–1918. This one, from 1917, is aimed very specifically at women, indicating that at this time women, in the United States at least, were regarded as having some measure of economic independence and also a personal view on the moral justification of the war with Germany.

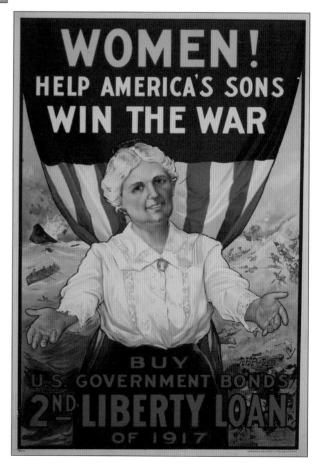

'The war and humorists. Exhibition.' The female figure of Anastasie with her great scissors had been an allegory of censorship since the French restoration of 1814 and may derive from the fourth-century ruler Anastase I. At the beginning of the war acts and laws gave powers of censorship to the military: the French still remembered that the Prussian Army in 1870 had simply read the press to know their movements. Everywhere, the sometimes difficult relationship between artists and censors was due to imprecise applications of overreaching laws. In most cases, it seems that self-censorship anticipated these difficulties.

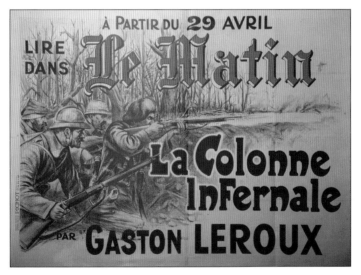

'Starting April 29th [1916] in "The Morning" read the infernal column by Gaston Leroux.' The author of *The Phantom of the Opera* (1910), journalist Gaston Leroux knew how to prick the reader's curiosity. Literary series were prized by newspapers because they ensured a faithful readership. The war only changed certain themes, and posters advertising famous authors continued the bookshop-poster tradition of the early nineteenth century. For authors, a series secured a steady income and was a good way to avoid being censored. For example, Barbusse's *Under Fire* was left uncut because it proved too complicated to collect the instalments.

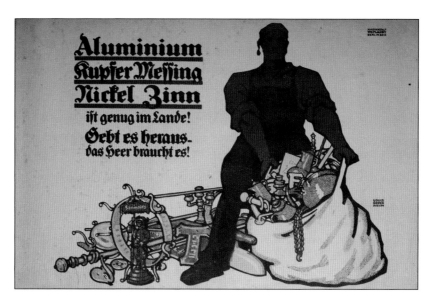

'Aluminium Copper Brass Tin are sufficient in the land. Bring them out – the Army needs them!' Louis Oppenheim's triumphant Michel (an allegory of the German common man) distracts attention from Germany's weak point. The British naval blockade had prevented Germany from importing many of the goods it needed for the war effort. The metals mentioned here were largely used to produce shells. Collecting resources was carried out to an even greater degree than in other countries, and occupied territories were systematically combed for their resources. Despite their efforts, German industries had to develop 'substitution materials' ('Ersatz Material') in innumerable fields.

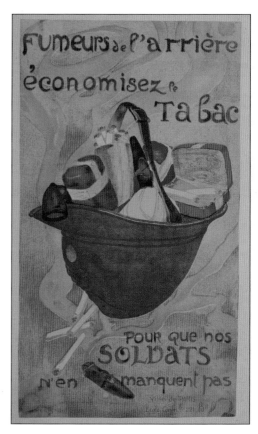

'Home front smokers. Save tobacco so that our soldiers are not deprived.' In 1917 the city of Paris held a contest in schools asking children to draw a series of posters about rationing. During the early twentieth century, smoking was regarded as part of a masculine, virile identity, and was even considered a sign of elegance. Giving up luxury goods for soldiers at the front was a socially encouraged manner of expressing one's debt to the sacrifice the combatants were making. Because children were not supposed to smoke (an unofficial practice that nevertheless developed greatly during the war), it is more than probable that this poster's theme was imposed by teachers.

'With the card – we will have little but we will all have some. Break your sugar in two today to have some tomorrow.' Yvonne Colas has carefully drawn a sugar-loaf to illustrate the text. Children were no longer passive or reduced to the role of potential victims justifying the soldier's fight but, for the first time, were targeted specifically by propaganda. They were to be mobilised like their parents and even, as is the case here, helped to monitor the grown-ups' conduct.

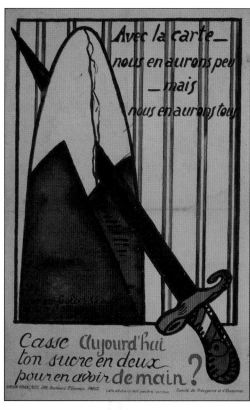

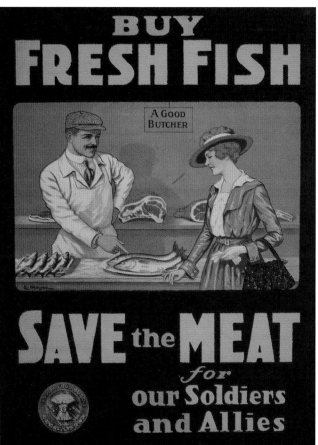

Another public information poster, implying that buying less meat would in some manner assist the fighting men. This basis of such a claim was highly doubtful, in view of the fact that most soldiers received army rations that were monotonous, nutritionally poor and often of indifferent quality. Fresh fruit and vegetables were conspicuous by their absence and most troops would have given a week's pay for the succulent fish illustrated in this poster.

The war disrupted normal economic patterns and food became a major logistics challenge. For British troops alone some 3,250,000 tonnes of grain were sent to France during the war, despite the need to import 85,000 tonnes per month. The entire Australian and New Zealand meat production went to the war effort. But everywhere, efforts proved insufficient and rationing had to be introduced. Landlocked Switzerland produced a poster showing the great diversity of cards issued during the war.

'War prisoner's home-coming. Information. Advice. Help.' The German soldier here is returning from a French camp, where his clothes had been marked PG (Prisonnier de Guerre – Prisoner of War). During the war over 9.5 million men became prisoners of war. German soldiers were kept in camps until the second half of 1919 as a means of applying pressure to Germany before the signing of the Versailles Treaty. The artist captures here the poignant moment when the returning soldier gets off the train but has no one to meet him. Despite the poster's reassuring message, the social and economic reintegration of veterans proved even more difficult in defeated Germany than elsewhere.

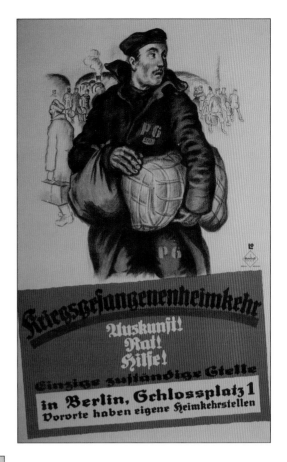

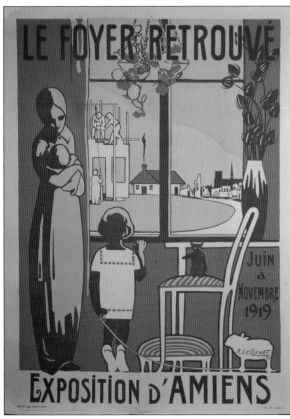

'The recovered home. Amiens show.' The very modern graphic design of Le Cornec's poster uses large surfaces of a single colour to offer a positive, dynamic view of the reconstruction. It is a reassuring view of a perfect household. The growing family echoes the rebuilding of Amiens, recognisable by the cathedral's silhouette. However, though a bright future is promised by the poster, the barbed wire would not be completely removed from the Somme battlefields until 1931. The reconstruction process would often be long and difficult; many press articles compared the barren lands to a new far-west.

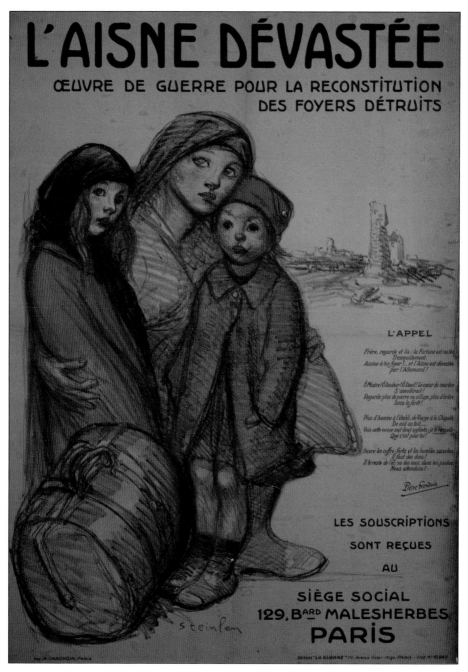

'Devastated Aisne. War Charity for the reconstruction of destroyed homes.' This Steinlein realist charcoal drawing sticks to an accepted aesthetic in order to transmit the dignity and suffering of the civilians and encourage help to change their current situation. As early as the German withdrawal in 1917 many displaced French families returned to their homes, only to find them wrecked by the war. Charity Days did not end with the war: on the contrary, they would go on well into the 1930s, focusing on war victims, wounded men, orphans and the plight of those returning to devastated homes. The great celebrations of 14 July 1919 also served as a way of collecting money for the reconstruction.

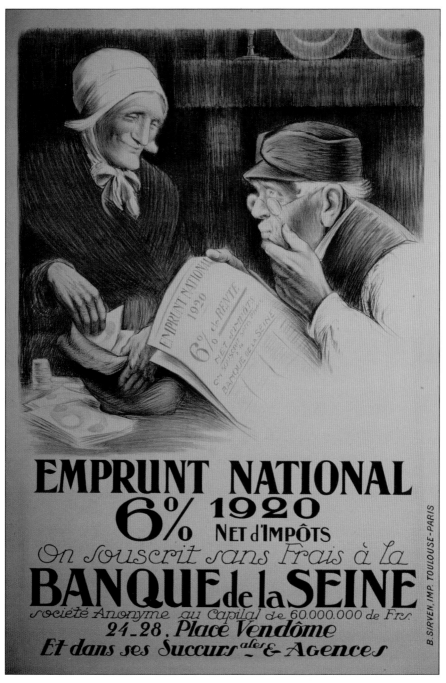

EMPRUNT NATIONAL
6% 1920 NET d'IMPÔTS
On souscrit sans Frais à la
BANQUE de la SEINE
société Anonyme au Capital de 60.000.000 de Frs.
24-28. Place Vendôme
Et dans ses Succursales & Agences

B. SIRVEN, IMP. TOULOUSE-PARIS

'National Loan 6% after tax – 1920. We subscribe without fee at the Bank of the Seine.' This poster reveals a certain mental demobilisation, for the war and its consequences are absent. The artist makes no reference to ideals or altruistic feelings, but depicts the simple common sense of a couple looking for the best investment. The figure of the French peasant is very traditional: age symbolised experience, while the family's rural background was a reassuring guarantee of a safe, secure operation. Such farming imagery is relatively rare during the war, as propaganda often insisted on the figure of the soldier and was aimed at the more easily accessible urban classes.

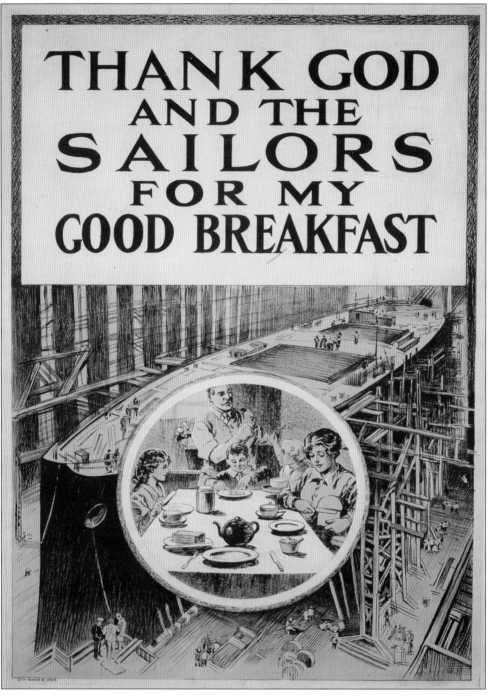

THANK GOD AND THE SAILORS FOR MY GOOD BREAKFAST

This unusual and complex image juxtaposes a family eating and a half-constructed ship. The message – that ship construction had a direct link to having food on the table – was a very appropriate one by 1917, the date of this poster. Such messages were a sign of the times, for this image would have meant little two years previously, when there were no food shortages, but in the intervening years the U-boat campaign had come close to breaking Britain's vital maritime supply lines. The artist 'TF' has not been identified.

Chapter 6

Films

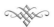

At the turn of the twentieth century the cinema was a relatively new social phenomenon. Its rise reflected the fact that, for the first time, working men and women had more disposable income with which to enjoy themselves. Cinemas were particularly popular with the working classes, as they required no social separation, were usually easy to reach and cheap to attend, and were open at convenient times. In London in 1914 there were over 1,000 cinemas, or public halls that showed films, in Paris over 700 and across Germany some 2000. In the era of silent movies there were no language barriers so films made in Europe or the United States could be shown anywhere. As the war progressed, this international market shrank as 'enemy'-made films were banned from the screens but in their place appeared more home-produced films. Indeed, the renowned Fritz Lang began his illustrious career in German cinema at this time. Gradually, all of the countries involved in the war began to produce newsreel film of the battles, some genuine, some less so, in an attempt to show how well the war was progressing. Probably the first documentary was made by A.K. Dawson, a cameraman attached to the Austro-Hungarian Army, who made an historic short film about the Battle of Przemysl in 1915; this film was widely shown in the United States. However, the best known and most historically significant of this genre was *The Battle of the Somme*, released in the summer of 1916.

This was the first film ever made that attempted to portray some of the realities of war to a mass audience. Audiences accustomed to entertainment and an escape from the realities of day-to-day life found the scenes of devastation, dead and wounded unlike anything they had seen before and many images are still contentious today. Such was the film's effect that it was watched by more people in Britain than any other film until *Star Wars* was released in 1977. It also reinforced the role of the cinema as a major means of showing propaganda in a more subtle way. So important was the cinema

that by 1917 Germany had partially nationalised its film industry by the formation of the 'Universum Film AG' and in the United States, Britain, France and other European countries the cinema was increasingly being used to send powerful messages to a wider audience than posters could reach.

The advent of the 'entertainment' war film was only a matter of time, of course, and it is ironic that the first was actually a silent comedy film by Charlie Chaplin called *Shoulder Arms*. Few war films followed the theme of comedy though, for after 1918 anti-war sentiment grew quickly and films were used to bring home the true horror and futility of the war. Films such as *The Big Parade* (1925) and *What Price Glory?* (1926) had anti-war themes, and with the advent of sound *All Quiet on the Western Front* (1930) became an international success. Many of these films used genuine locations and even employed veterans who re-enacted their military roles for the camera, and these early films have a ring of authenticity that more modern ones lack. Using aviation as a theme, some productions such as *Wings* (1927) and *Hell's Angels* (1930) were able to use genuine aircraft that today would be priceless museum pieces. The posters produced for these films were usually colourful, dramatic and sensationalist, and they have become collector's items in their own right. Great War cinema has remained topical: in 1969 *Oh What a Lovely War* – an eclectic mix of music, comedy and satire – was released and is arguably the best of its type ever to be produced. *All Quiet on the Western Front* was remade in both 1979 and 2009, and in 1981 *Gallipoli* was a surprise box office hit. With the centenary of the war approaching, there has been a corresponding rise in interest among the public and a more balanced approach is now being taken by films such as *Under Hill 60* (2010), which was a true account of the work of Australian tunnellers. At the other end of the spectrum *Warhorse* (2012) has been an incredibly popular spin-off from the fictional stage play. When Charlie Chaplin filmed his Great War epic in 1918, he could never have guessed just what an enduring legacy would be the result.

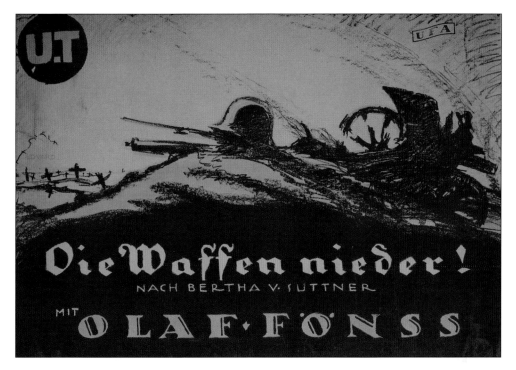

'Lay down your arms! By Bertha v. Suttner with Olaf Fönss.' Bertha von Suttner's 1889 best-selling pacifist novel describes the sufferings of a woman through four of the nineteenth-century's European wars. Inspired by the Austrian Nobel Peace Prize winner, the film was first released in August 1914, and then again after the conflict, when its posters featured a German steel helmet that did not exist in 1914. The re-release was probably an attempt to show the film's relevance in the aftermath of the war.

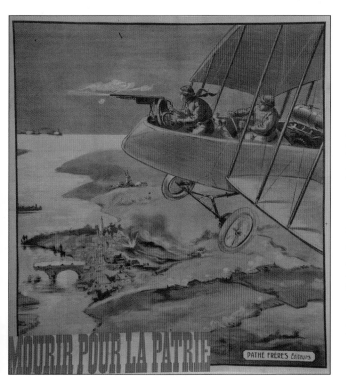

'To die for country.' At the beginning of the war no real system existed to capture the fighting on film. In France private companies were allowed to make their own newsreels, but in March 1915 the Section Cinematographique de l'Armée (Army Film Section) was set up. This merged in 1917 with its photographic counterpart to create a more centralised source of images for propaganda purposes. By then the battle was on for world-wide public opinion and all nations competed to produce their own versions of events.

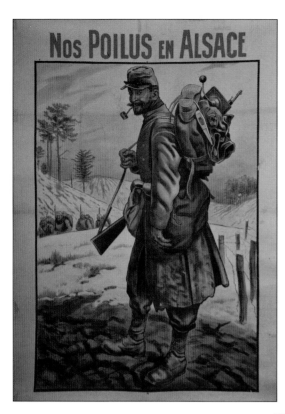

'Our Poilus in Alsace.' The poster artwork for this 1915 documentary film is finely detailed and realistic: for instance, the unofficial corduroy trousers are typical of the transition period from the red to the blue horizon uniform. The poster is directly copied from an image showing a cook with a coffee-grinder on his back at the Hartsmannwillerkopf. This summit on the Franco-German border saw heavy fighting in 1915. The soldier's portrait was also turned into a postcard: during the Great War images could already be re-employed in various promotional ways.

'Austrian weekly war report of North and South, with authorisation of the Royal and Imperial Army High Command and of the War Ministry. Austro-Hungarian film industry.' The war enabled Austria-Hungary to develop its own newsreel industry, an area previously dominated by the French. Its first weekly newsreel started in September 1914, before Sascha-Film also took on this new market, with more success. The poster is a typical representation of hunched-down Austrian soldiers attacking under a hail of bullets. The artist, Egger Linz, would further accentuate this tension in his most famous painting 'Those who have lost their names, 1914'.

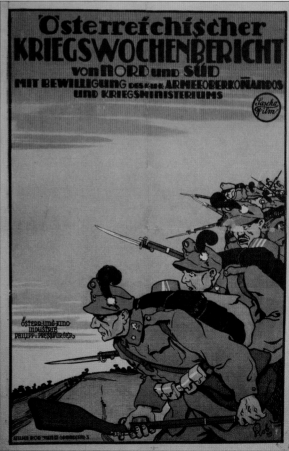

'The French woman during the war.'
This 1918 newsreel, introduced by a
short fiction, summarised women's
new role in the conflict. The poster's
direct, simple style was even more
explicit. It combines various female
figures. The allegorical goddess
represents the ideals for which the
French were fighting, while the
traditional farmer taking on more
physical tasks and the new factory
worker symbolise the mobilisation of
the home front. But the central
image remains a reassuring maternal
figure faithfully waiting for her man's
letters: many soldiers saw the sudden
changes in the female role as a
menace to their masculine identity
and status.

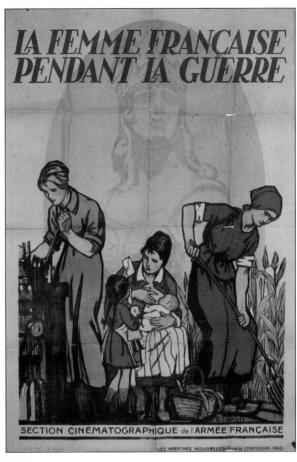

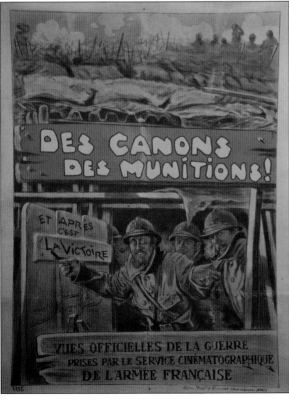

'Guns! Munitions! And after it's
victory! Official footage of the war
taken by the Film Section of the
French Army.' Newsreels had an
extremely important role in giving
the public a vision of the war. This
colourful poster (announcing a
black-and-white film) promises a
realistic view of the front and of the
trenches, while simultaneously the
cheerful men coming out of the
shelter on the lower half make it
clear that this official film aims at
lifting morale.

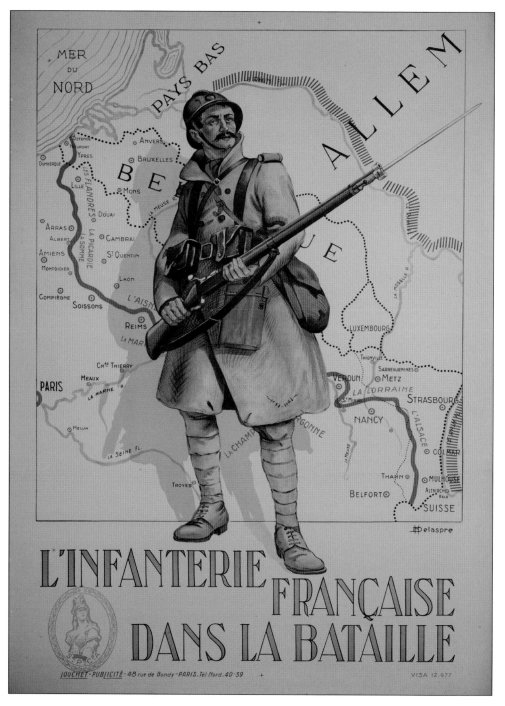

'The French Infantry in Battle.' The demand for images and a better understanding of the conflict remained high after 1918. Many families would treasure the official photographs they bought after the war, and these are still used to preserve family memories. *The French Infantry in Battle* documentary served a similar purpose: it is a chronological account of the military events taken from four years of official filming at the front. With the French Poilu defiantly standing guard before a map of the Western Front, the poster is a reminder of French tenacity throughout the war.

'Verdun. Just as the French soldier lived it (in six parts). Place your bets (comedy in two parts).' Pathé Rural was first used in 1926. It was hoped that 'by bringing the cities to the villages', the rural emigration process would be if not stopped at least slowed. Pathé Rural therefore aimed at bringing educational films to villages but it was also a way to cut costs. Emile Buhot's 1927 *Verdun* is part of the commemorative production industry that blossomed ten years after the conflict. However, as this poster makes clear, serious films were not always sufficient to attract the public.

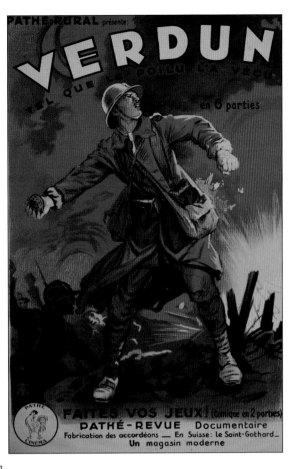

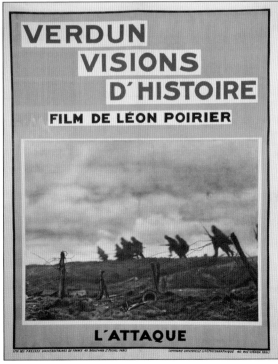

'Verdun visions of history. The attack.' Refusing to adopt an American melodramatic style, Léon Poirier decided to make a more authentic film. In 1927 he shot *Verdun visions of history* on the actual battlefields using, for the first time, both French and German actors. The film's epic description of the battle was also an epitaph to all war victims and a means of educating people against war. Ironically, the superb images, filmed as if from the soldier's viewpoint, are still used nowadays in war documentaries.

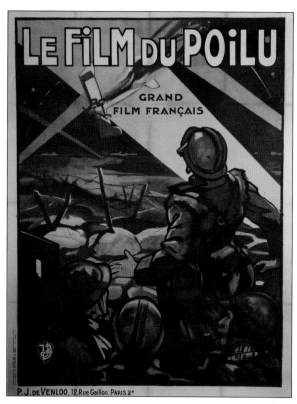

'The film of the Poilu.' Like many filmmakers of the late 1920s and early 1930s, Henri Desfontaines wanted to create authentic images by mixing archival footage, fiction and first-hand accounts. There is a moralising, rather pacifist tone to them, and such films condemned the supposedly increasing forgetting of the war. With the help of shocking images, it tried to reactivate the horrors of the trenches in order to prevent history from repeating itself. This was typical of French war veterans in the late 1920s and in particular of Daniel Mandaille: twice wounded at Verdun, he became a moral guarantor and also acted in three other films on the Great War, advocating realism in style and pacifism in content.

'Block-heads.' Laurel and Hardy's 1938 comedy starts with a serious subject: Stan Laurel doesn't know the war is over and is still standing guard where he was left before his unit attacked. Later, Oliver Hardy believes his former mate has lost a leg and decides to help the veteran. Though the rest of the film is based on classic comedy twists of two 1928–1929 shorts, it reveals the lasting impact of the Great War, especially at a time when the United States was looking on at the rising tensions in Europe.

Despite the general trend in the late 1920s, not all films aimed at educating their viewers or at making a statement against war. The comedy *Doughboys* accumulates different sketches without aiming at any realism: for example, Buster Keaton accidentally volunteers for the army. Minor films would also use the Great War as a backdrop.

'All quiet on the Western front.' By the end of the 1920s, like many others in the film industry, Carl Laemmle Sr had become a pacifist, despite his 1918 pro-war films. His adaptation of Erich Maria Remarque's novel started on Armistice Day 1929. The poster, showing Kemmerich's agony, focuses on the mutilation and death of a whole generation. Despite glowing reviews, the film would be cut in many countries, not least in Germany, where Nazi supporters disrupted the film's premier by releasing mice and coughing powder – the resulting rioting led to the film being banned. Goebbels had it censored and forced Remarque into exile.

'Richard Oswald's 1914. The last days before the world fire.' Richard Oswald's 1931 anti-militarist film was severely criticised by the German conservative press and triggered a censorship scandal. Based on the diplomatic records of the Imperial Court, it showed the events leading up to the outbreak of the Great War. Though the poster focuses on the most dramatic moment – Gavrilo Princip being arrested after killing Archduke Franz-Ferdinand – the film was disappointingly stiff. Oswald went on to make, among many other productions, the first horror film. As a Jew, he then had to flee Germany when the Nazis took power.

'Douaumont. Verdun's hell.' Poster and film alike are not centred on individuals but try to embrace a common experience of total war: Heinz Paul offered a pacifist vision of both sides through archival evidence. His 1931 production is therefore more concerned with the multitude and realism than with individual story-telling. Creative liberties were still considered to show a lack of respect for the sufferings caused by the war.

'No man's land. Never again!' Victor Trivas, a German of Russian origin, adapted Leonhard Frank's work to create a pacifist film: as a symbolic reflection on the creation of Europe, the war is in fact off-screen. Five soldiers from various countries are stuck together in a shelter in no-man's-land and progressively learn to survive together. As in many of the 1930s films, hatred of the enemy evolves into hatred of war in general. In this case the film is also a call for class consciousness to prevent capitalist wars where only the lower classes suffer.

'Grand Illusion. The masterpiece of French cinema.' *Grand Illusion* first came out in 1937. Mostly set in a prisoner of war camp, it shows values like patriotism, honour and sacrifice, but also defines the tensions between social classes, and the hopes for peace despite these differences. More complex than most previous films on the subject, it was a worldwide success, though it disappeared, along with the original poster pictured here, from French screens in 1939 as it was seen to encourage alliances with the enemy.

Interest in war films fluctuated with time, and they were often released to coincide with war anniversaries. Compared to a number of generally anti-war films such as *What Price Glory?* (1926), *Sergent York* was slightly different; a biopic of the United States' most decorated soldier, it remained reasonably faithful to the true story, earning Gary Cooper an Academy Award for best actor in 1941. It is somewhat ironic that within a few months of the release of the film, the United States would once again embark on a world war.

Paths of Glory was a 1957 film by Stanley Kubrik. With a typically anti-war stance, it was a dramatised version of the real-life trial of four French soldiers who were selected at random for execution after a failed mutiny in the wake of the disastrous Nivelle campaign of spring 1917. In France this film was regarded as an insult to the country's contemporary involvement in the Franco-Algerian wars, and it was not released to the public until 1975. This particular poster carries the rare 'Passed by Censor' stamp.

Most films about the Great War made since the 1920s have been of a critical or anti-military nature but this film, based on a book written in 1938 by American screenwriter Dalton Trumbo (1905–1976), took this stance to a new level. It is a virulently anti-war story about a young soldier, Joe Bonham, left deaf, blind, dumb and quadriplegic after being hit by a shell. It was broadcast as a radio play in 1940, and adapted for the screen in 1971 in the midst of the United States' unpopular involvement in the Vietnam War. The stage play, first adapted in 1982, has since been performed worldwide.

Chapter 7

After the War

The war did not end with the fighting. It would be another seven and a half months before peace would be officially signed in Versailles with Germany, and in other cities around Paris with the other defeated countries. By then, cross-border skirmishing (when it was not outright civil war) had erupted throughout central and eastern Europe. Entire new countries, such as Poland, Czechoslovakia and the Baltic states, had appeared, while others were reduced or recomposed. New political systems such as Bolshevism were threatening more traditional structures. On a more individual level, countless families were in mourning and millions more suffered from physical or mental wounds. About one in eight of the men who served had died. The consequences of the Great War would continue to profoundly affect societies long after its conclusion.

This impact was naturally also reflected in posters of the postwar period. Immediately after the conflict the return of the soldiers was on everyone's mind but the sacrifices endured also had to be honoured: remembering the dead, taking care of the wounded and rebuilding the devastated regions was far more important than the archetypal image of the 'roaring twenties' would have us believe.

The political turmoil also created innovative posters. Though they were not concerned with the legacy of the Great War, the Russian revolutionary artists looked towards a much brighter future, and they brought new abstract figures and a modernist approach. The influence of cubism and of simplified forms grew in the inter-war years. The clear, almost architectural drawing concentrated on the message without insisting on the artist's virtuosity. But these new approaches did not entirely eliminate well-tried representations. Themes of the Great War were reused constantly: the figures of the warrior and of rallying symbols, hatred of the (political) enemy, the glorious past, the sacrifice of the dead for the living were all employed to justify different convictions. Examples covering the variety of

the political spectrum demonstrate that war was still a central preoccupation: the right reacted to the rise of communism and produced a wide range of violent, visually striking posters. The Nazis, who had never accepted the 1918 defeat, would continue referring back to the Great War in their Second World War propaganda. Most left-wing posters remained in the more typical charcoal drawing style and promoted peace as a solution to the challenges of the times.

At the same time remembrance remained a strong theme. Pilgrims visited the battlefields in search of a lost soldier or to see what the landscape looked like. This phenomenon has not waned in a century, and new generations continue to travel to Thiepval and other monuments. At regular intervals, especially on anniversary dates, new posters are still produced to commemorate the Great War, or at the very least to evoke it – a sure sign of the vitality of remembrance and of the lasting impact of this period on our societies and our world.

This simple poster was printed by V. Bouvier in Loos in 1918. Posters of this type appeared in their hundreds, as areas were gradually freed from German rule by advancing Allied troops. Few survived, and today there are only a few very rare examples of the genre of liberation posters.

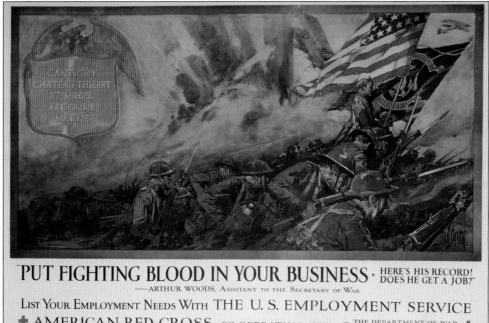

"PUT FIGHTING BLOOD IN YOUR BUSINESS · "HERE'S HIS RECORD! DOES HE GET A JOB?"
——ARTHUR WOODS, ASSISTANT TO THE SECRETARY OF WAR

LIST YOUR EMPLOYMENT NEEDS WITH THE U. S. EMPLOYMENT SERVICE
✚ AMERICAN RED CROSS CO-OPERATING WITH THE DEPARTMENT OF WAR THE DEPARTMENT OF LABOR ✚

Not all posters were created to get men to enlist in the armed forces; this superb artwork by Dan Smith (1865–1934) was designed to help men find work after the fighting was done. A joint venture between the American Red Cross and the US Employment Service, it depicts the bravery of the US Marines as they fought their way towards victory, listing their battle honours, and it asks that the soldiers be given work on their return. The reality was that, despite government promises to the soldiers (Lloyd-George's famous 1918 election speech promising a 'land fit for heroes' being a prime example), after 1918 tens of thousands of disillusioned ex-soldiers in Britain and the USA found themselves unwanted and unemployable as the war economies collapsed.

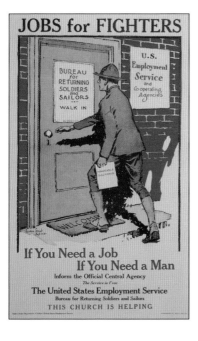

On a similar theme, an American soldier clutching his 'honourable discharge' certificate enters an employment exchange. This poster was produced in 1919 by the US Employment Service and was drawn by Grant Gordon (1875–1962). Although born in San Francisco, Gordon was sent to study at the Fife Academy in Scotland before returning to San Francisco in 1896. As an on-the-spot war artist he witnessed first hand both the Boer War and the Mexican Revolution. His sketches were published in *Harper's Weekly*, and the long voyage home by sailing ship started his fascination with marine subjects. Today he is regarded as the United States' premier maritime artist.

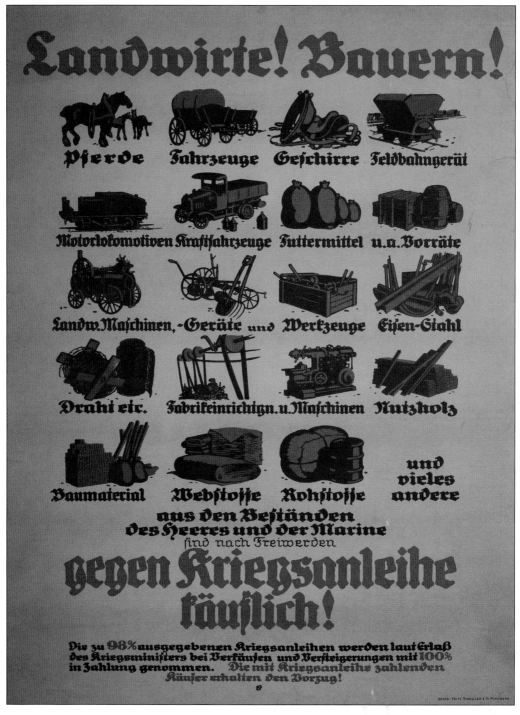

'Countrymen! Farmers!' After the war the immense stocks of equipment held by the army and navy were no longer needed. Like other nations, the Germans auctioned them off. In this case, they sold them against war bonds: buyers paying by this means would get priority and better prices. For the State, this was a way of reducing the incurred war debt. These financial problems would plague the young Weimar Republic, and the question of reparations would only come to a final close in 2011.

'Our Lady of Lorette 12 June 1932. Inauguration of Bishop Julien's monument and 5th march of the families of the dead.' Grief and mourning dominated the postwar years. Notre Dame de Lorette, located on the hill-top overlooking the Artois battlefields, was to become the biggest French cemetery, containing the bodies of 42,000 soldiers. The 170ft-high lantern tower was inaugurated as a memorial in 1925 and the chapel was blessed in 1927 by Bishop Julien, who was instrumental in the rebuilding of the region. As so often happens, the mourning of individuals prompted the State to act in creating an official place and monument that are still actively involved in Remembrance today.

The seeds of the common poppy *Papaver rhoeas* can lay dormant for a hundred years, and a single plant can produce 60,000 seeds which burst into life when soil is disturbed. The shelling on the Western Front resulted in vast poppy fields, which soon became a potent symbol of the war. On 11 November 1921 the Royal British Legion held its first Poppy Day, a tradition that was briefly adopted by the United States. This British poster, with its famous lines from McCrae's poem 'In Flanders Fields', was produced in 1925 to encourage donations to aid US ex-servicemen residing abroad. It was a little-known fact that after the war many hundred Americans still lived in England and other Commonwealth countries, and several hundred had elected to remain in France.

145

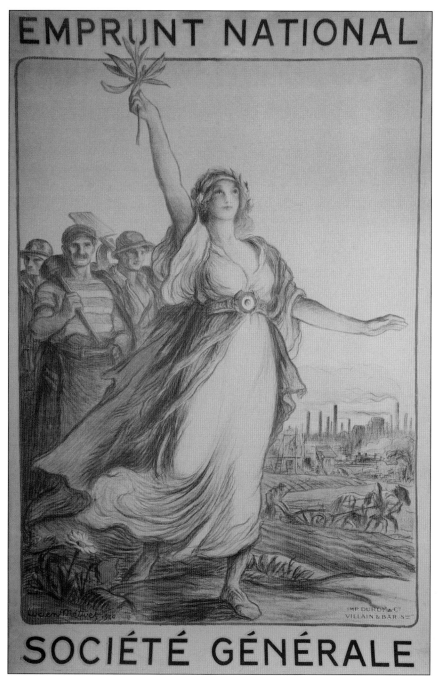

'National Loan. General Society.' Here the allegory of Victory, with a shell and a poppy at her feet, leads not soldiers but battalions of workers. The rebuilding of France is central to many postwar images, with posters insisting on the notion of rebirth by contrasting ruins and reconstruction. Here the land is being literally reconquered: the plough promises crops and fertile lands, and houses announce new comfort, while the train and factories show that a productive economy is already under way. In the warm colour of the sun, this poster offers a bright future to all – in particular to those who invest in the new loan.

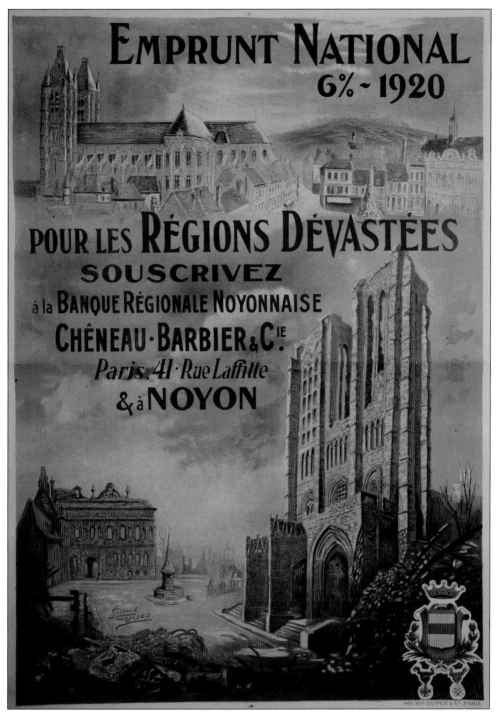

'National Loan 6% – 1920 for the devastated regions, subscribe to the regional bank of Noyon County.' Reparations from Germany were supposed to cover the costs of the conflict, and the success of the wartime loans made it all the more tempting for governments to launch new loan schemes after the war had ended. These loans were aimed at paying veterans' pensions and rebuilding the country. To highlight this point, the poster compares prewar buildings with their condition in 1920.

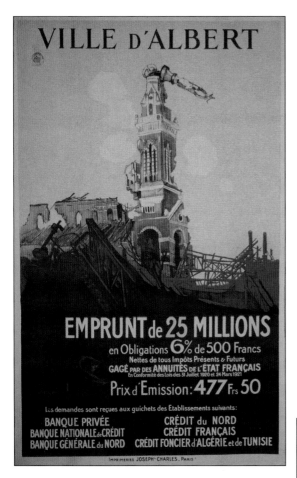

VILLE D'ALBERT

EMPRUNT de 25 MILLIONS
en Obligations 6% de 500 Francs
Nettes de tous Impôts Présents & Futurs
GAGÉ PAR DES ANNUITÉS DE L'ÉTAT FRANÇAIS
En Conformité des Lois des 31 Juillet 1920 et 24 Mars 1921
Prix d'Emission: 477 Frs 50

Les demandes sont reçues aux guichets des Établissements suivants:

BANQUE PRIVÉE CRÉDIT du NORD
BANQUE NATIONALE de CRÉDIT CRÉDIT FRANÇAIS
BANQUE GÉNÉRALE du NORD CRÉDIT FONCIER d'ALGÉRIE et de TUNISIE

IMPRIMERIES JOSEPH CHARLES, PARIS

'City of Albert. 25 million loans in 500 Franc 6% bonds.' The town of Albert was heavily shelled and severely damaged, and in 1915 the basilica itself was hit, leaving the statue of the Virgin Mary leaning down. A legend grew around it that the war would come to an end when the statue fell, but the basilica was completely destroyed by the British during the German spring offensive of 1918. More than three years later the leaning Virgin nevertheless still symbolised the devastation of the city, the reconstruction of which would go on until the early 1930s. For this reason, in 1920 two more national loans (and countless local ones) were needed for reconstruction.

This British poster by John Hassall (1868–1948) from late 1918 illustrates the start of the reconstruction of the devastated areas of northern France with a rather forlorn attempt by a man and his son to re-tile a shattered house. In fact, some 1.5 million French civilians had been left homeless and such was the level of destruction that many villages were simply never rebuilt. Hassall was one of Britain's premier illustrators and at his New Art School in Kensington had numbered Bert Thomas and Bruce Bairnsfather among his students. The Kodak Girl he created in 1910 was used by the company until the 1970s, but he has gained more lasting fame as the creator of the much-reproduced 'Skegness is So Bracing' poster.

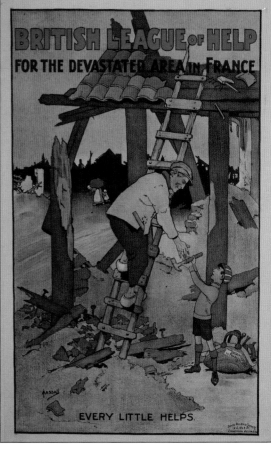

BRITISH LEAGUE OF HELP
FOR THE DEVASTATED AREA IN FRANCE

EVERY LITTLE HELPS.

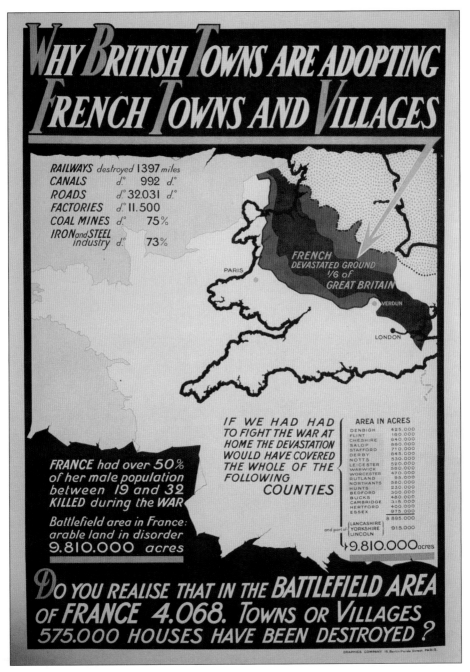

An illustration that is interesting more for the information it carries than its artwork, this 1919 poster is promoting the adoption of French towns by British cities to aid reconstruction. One reason for the slowness of rebuilding was simply the lack of men. France had lost 1,357,800 dead and 4,266,000 wounded, of whom 1.5 million were permanently maimed. These losses comprised some 73 per cent of the 8,410,000 men mobilised. Funds were sorely needed, but so too were men, and in farming regions free land and housing were offered to immigrants. Many thousands of displaced Belgian agricultural workers, as well as Czech and Polish miners, settled in northern France after the war.

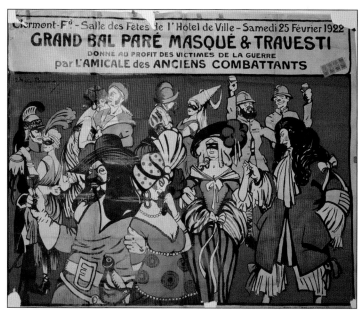

'Great "dressed-up, masked and travesty" ball given for the war victims by the veterans' association.' Calls for generosity did not all rely on making people feel guilty. This unusual poster seems to correspond to the idea of the 'roaring twenties'. The French Poilu is represented as a boisterous party-goer. This entertaining event could probably only be depicted in this way because it was organised by veterans themselves. It must be added that the Poilus are included in a company of noblemen, literary figures (the long-nosed Cyrano de Bergerac) and glorious historic soldiers.

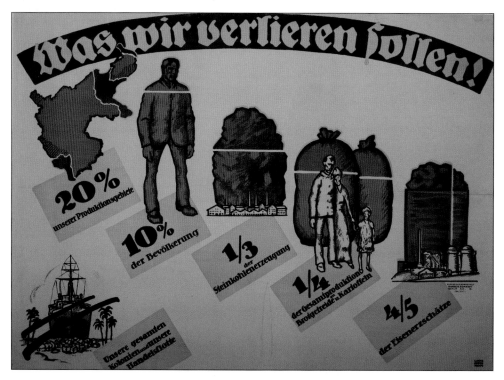

'What we must lose. 20% of our productive land. 10% of our population. $^1/_3$ of our coal production. ¼ of our bread and potato production. $^4/_5$ of our iron ore. All our colonies and merchant ships.' This summary of the Versailles Treaty barely exaggerates the facts. The treaty was denounced as a 'Diktat'. But what shocked most Germans was the fact that they were held responsible for the war. For years criticising the Versailles Treaty would be the cornerstone of German politics.

'Volunteers of all arms protect Berlin. Join the Reinhard Brigade.' For Germany, the Great War ended in a revolution, sparked when sailors in Kiel mutinied against their officers. The unrest spread and soon German soviets had mushroomed throughout the country. The Kaiser abdicated on 9 November and fled to the Netherlands, and German officers reacted by organising unofficial 'Free Corps'. These far-right paramilitary units fought the 'Bolshevik danger' inside and outside Germany, and soon became a threat to the young Weimar Republic. Many Free Corps members would become the link between Great War veterans and Nazi leaders. The Reinhard Brigade was instrumental in the crushing of the Spartakist (communist) uprising in Berlin in January 1919 and in the fighting against the Poles.

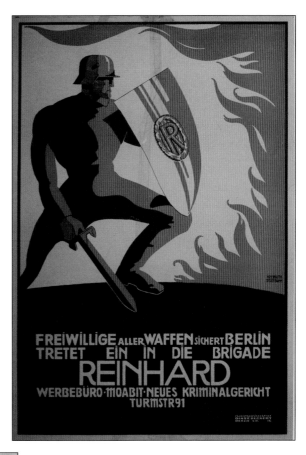

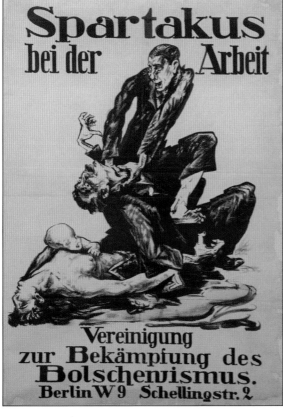

'Spartakus at work.' The 'Union for fighting Bolshevism' was the reaction of the German conservative upper middle-class, which feared that the November revolution would follow the Russian revolution and not only create a new democratic political system but also become a menace to their property. It started a costly poster campaign where Great War artists did not hesitate to use the most violent representations. The unflinching message systematically had the communist drawn as a depraved murderer or an inhuman beast. Thus, at the beginning of 1919 the new social-democratic republic was, surprisingly, helped by reactionary forces.

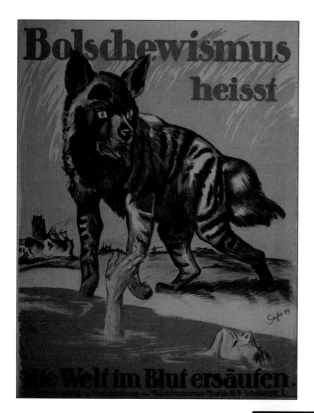

'Bolshevism means the world drowned in blood.' The wolf, as a savage beast, needed no explanation: predatory animals had long been used by all political sides as a metaphor for the enemy. The beastly representation was, in this case, financed by the 'Union for fighting Bolshevism'. As is often the case with imagery spawned from fear, these posters were particularly violent and extreme. This imagery of total rejection left no room for compromise. It would subsequently be re-employed by the Nazis to characterise the 'Eastern danger'.

'The country is in danger. Great financial means are needed for protection in the East. Help now!' Great War posters represented a breakthrough for political propaganda in Germany. The new images brought on a new radicalisation in society. The figure of the revolutionary foreigner (from Russia) dates back to the nineteenth century, when anti-democratic movements used the same iconography. Slavs were seen as a cruel, despotic race. These images were reinforced by the burnt land found after Russian retreats on the Eastern Front, and by the chaos of the Russian revolution. Fear of Cossack cruelty was still played on during the Cold War.

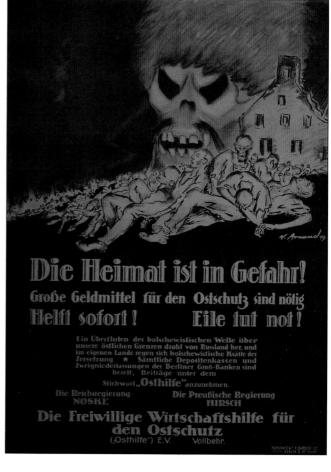

'The Polish wolf covets your homeland. Do not tolerate it!' As early as 1918 fighting broke out along the disputed border between Germany and the new Poland. In the east, many German towns were surrounded by Polish-dominated countryside. The fighting for Upper Silesia would continue until 1921. Even in 1926, when the international situation was more peaceful, Germany only officially recognised its western borders in the Locarno Treaties. The dehumanised menace contrasts with the wealthy industrial region.

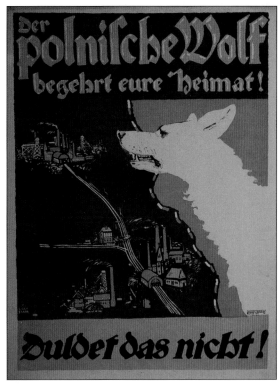

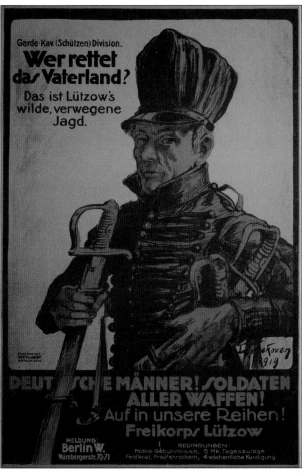

'Who saves the Fatherland?' Turning to a glorious, adventurous past was a way of erasing the painful defeat of the present. Ludwig Adolf Wilhelm von Lützow had organised a Free Corps during the Napoleonic wars. Though its military impact is still debated, the Black Troop that he raised was famous for its bravery and was immortalised in Theodor Körner's poem 'Lützow's wild, daring hunt', as mentioned on this poster. For all these romantic reasons, the Berlin-based Lützow Free Corps formed in 1919 by Major Hans von Lützow used the historic figure as a recruiting tool.

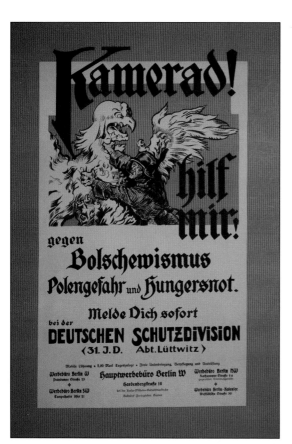

'Comrade, help me! Against Bolshevism, the Polish danger and hunger, enlist immediately into the 31st Protection Division.' This poster for a semi-official infantry division combines the main subjects of German concern in the immediate postwar period. Hunger was by no means solved by the armistice as the Allies continued to blockade ports until the peace treaty was signed. The new regime not only had to deal with communist uprisings throughout Germany but also faced the attempts of the newly reborn Poland to annex by force its neighbouring regions. These various dangers are depicted here in a typical beastly incarnation. The poster methodology of the Great War directly mirrored the new situation.

'Forward March, Gentlemen!' The Death's Head became the badge of the Croix de Feu, a paramilitary group of French soldiers decorated for their bravery in battle. Led by Colonel De La Roque and relying on the so-called trench fraternity, it developed an anti-parliamentarian, authoritarian view. Though it did not actually march on Parliament during the 6 February 1934 demonstration, the Croix de Feu became the symbol of a potential Fascist takeover for the French left.

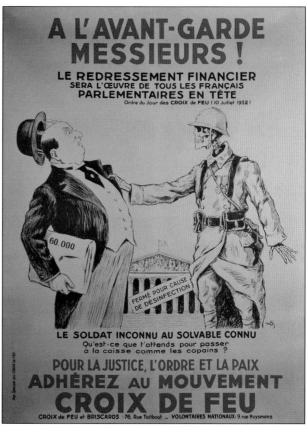

'Comrades. Protect the German Republic! Enlist for the East!' Though the Great War's aftermath led to the rise of extremism and totalitarian regimes, democratic movements did not remain passive. The newly founded German Republic, with its political capital ultimately in Weimar, was based on a centre-left coalition, which replaced the old black, white and red imperial flag with the flag of the nineteenth-century German democratic movement. This official poster from Dresden, listing the improved material conditions for soldiers, aimed at creating a professional army so that the government would not have to depend upon the Free Corps.

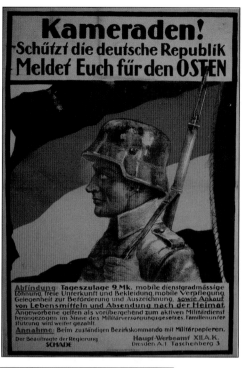

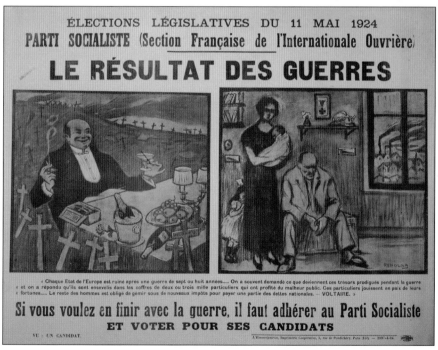

'11 May 1924 General Election. The result of wars. If you want to get rid of war, join the Socialist Party and vote for its candidates.' Despite the many upheavals of the left-wing parties in France, prewar pacifist policies were again promoted. The Socialist Party contrasts here the bourgeois profiteer with the unemployed war veteran. The latter's laurel-crowned helmet and medal are clearly visible on the wall above him. War is therefore denounced as an economic absurdity which impoverishes the majority.

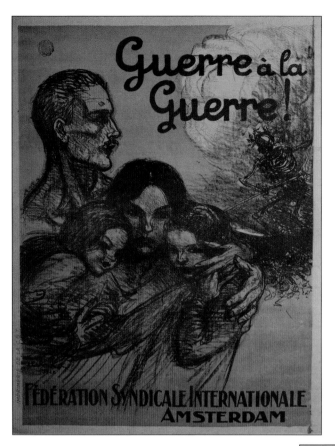

'War on war!' Théophile Steinlein (1895–1923) was one of the far-left's most famous artists, and after the war he was close to the newly founded French Communist Party and the CGT trade union. A year before his death he produced an anti-war poster that did not reflect explicitly the communist vision of an imperial war based on class-warfare considerations. Rather, it appeals to a pacifist mood by showing a family protected by the father from a laurel-wreathed Death. The Grim Reaper is clearly the only winner in war.

'Children. Don't play at war. Parents, if you want your children to live, prepare the moral disarmament, ban war toys. International League of Peace Fighters (LICP).' The Frenchman Victor Méric founded the LICP in 1931 and successfully attracted many intellectuals, including Stefan Zweig. Convinced that war was the product of poor education, the League put much of its effort into deconstructing all justification, glory or fascination for war. The notion of sacrifice for a cause was systematically replaced by one of meaningless death. Its extreme pacifism brought the number of members up to 10,000 in 1935 before fighting the Fascist regimes seemed unavoidable.

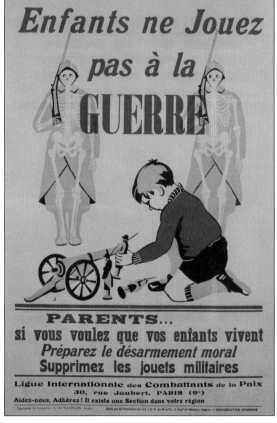

'National Service of French Railroads. Tourist automobile service. Battlefields.' As early as 1917 war tourism started in the 'liberated regions' after the German withdrawal to the Hindenburg Line. Families looking for the grave of a loved one visited the former battlefields, along with the simply curious. Tensions between pilgrims and tourists existed from the beginning. After the war numbers grew considerably. In 1929 2 million German visitors travelled to battlefields in France but their numbers were dwarfed by the massive pilgrimages of the Allied side. Still today, over 200,000 visitors (many coming from Great Britain or the Commonwealth) come annually to discover or rediscover the Somme battlefields.

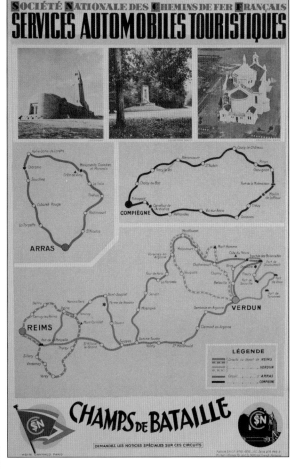

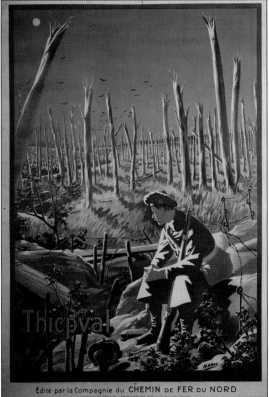

Édité par la Compagnie du CHEMIN DE FER DU NORD

A classic piece of imagery that carries no obvious message, this poster depicts a soldier of the 36th Ulster Division sitting in the splintered, moonlit remains of Thiepval Wood as crows wheel above. It is beautiful but has a slightly sinister overtone, and was commissioned from the artist Henri Grey to promote the 'Northern France Railway Company', presumably to encourage visitors and pilgrims to visit the old battlefields. Thiepval had been a particularly difficult objective to capture and was only overrun on 25 September 1916 after almost three months' fighting. The Frenchman Henri Grey was a prolific poster artist, specialising in colourful advertisements, although little is now known of him.

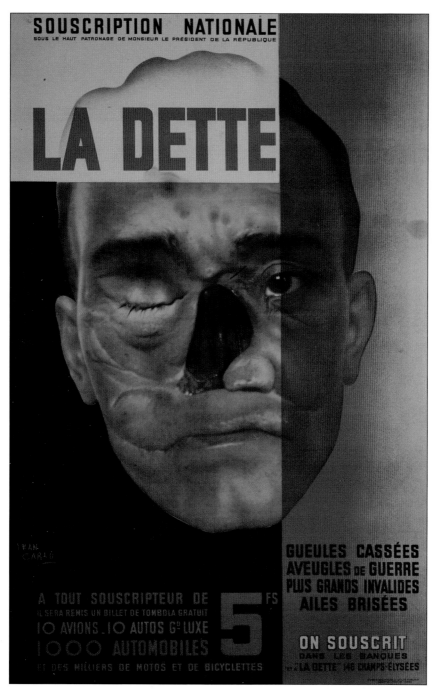

'The debt. Broken faces, war blind, major invalids, broken wings.' In 1931 the French 'Broken Face' association for facially disfigured war veterans started a raffle. Prizes included cars and even aeroplanes. The National Lottery was created in 1933, and until 2008 was a way of helping these disfigured men who lived in specialised homes similar to the Star & Garter in the United Kingdom. Jean Carlu innovated by using, for almost the first time, a photomontage approach. The reality of the suffering cannot be escaped: the direct gaze insisted that there was a moral debt all civilians had to pay towards wounded veterans.

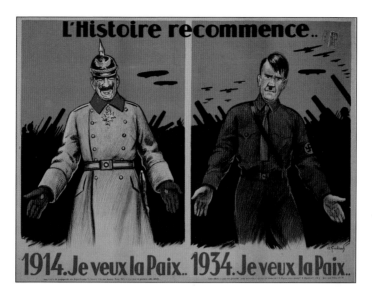

'History starts again. 1914: I want peace. 1934: I want peace.' The probable victory of the left in France encouraged nationalists to denounce pacifists as idealists. André Galland (1886–1965) here creates a clever parallel in order to present Hitler as the new Kaiser. Germany, and Wilhelm II personally, were still widely considered as responsible for the Great War. Though the poster doesn't mention the elections, it implies that the left-wing candidates would be too weak against an aggressive Germany: the Nazis had been the most outspoken group in their refusal to accept the 1918 defeat. This parallel, however, also shows that the French right did not understand what gave Nazism its unique character.

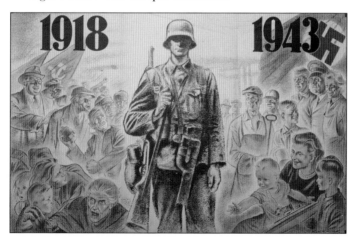

'1918–1943.' The German revolution and the proclamation of the Republic on 9 November 1918 were always associated by the Nazis with military defeat. They considered that the army had been 'stabbed in the back' by the Jews and the Bolsheviks. Twenty-five years after the events, this poster focuses on the figure of the German soldier, ambiguously drawn to represent both world wars, as the bastion against chaos and as a model of the new society. Even after Stalingrad, every German child was supposed to learn about the 1916 Battle of the Somme in order to understand the iron-willed German soldier who survived it and who went on to build the new Germany. The Great War remained a role model.

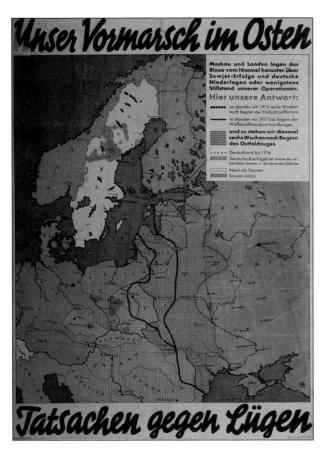

'Our advance in the east. Facts against lies. Moscow and London have lied constantly about Soviet successes and German defeats or about our operations' slightest set-backs. Here is our answer: in 1915, we stood there six weeks after the beginning of the spring offensive. We stood there in 1917 at the beginning of the armistice negotiations. And here we stand six weeks after the beginning of the Eastern campaign.' The reconquest of the Eastern 'savage' lands that belonged to the German 'vital space' was considered by the Nazis as a logical outcome of the Great War. Comparing Great War front lines with the first six months of Operation Barbarossa seems once again to go back to traditional propaganda: it puts the campaign into perspective but conveniently ignores that the 1917 Treaty of Brest-Litovsk allowed German troops to occupy all of the Ukraine.

The Great War remains a defining moment of our history. Remembrance is still strong today and takes on many shapes. Armistice Day still has a powerful meaning in both Britain and France. Visitors on the battlefields try to understand what happened and focus increasingly on the war experience of the men. Some see these men as titans who fought for our freedom, others would rather insist on today's attitude of reconciliation and peace. In all these cases, events and activities (ranging from official ceremonies to private tours and battlefield walking) still mark anniversaries and other dates. For the 80th anniversary of the Thiepval monument, the Historial Museum decided to devote a whole exhibition to recounting the lives of the British soldiers who died on the Somme and have no known grave. It illustrates the ways they have been remembered since then. Also by showing the faces of these individuals, the exhibition's poster reminds us that they are missing but not forgotten . . .

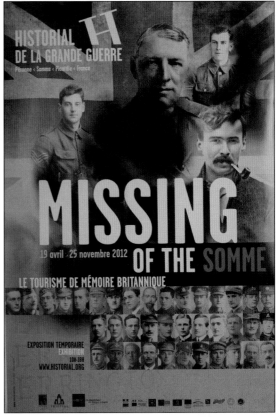